Contre-Jour

a triptych after Pierre Bonnard

GABRIEL JOSIPOVICI

CARCANET

First published by Carcanet Press in 1986.

This paperback reissued in 1998 by
Carcanet Press Limited
4th Floor, Conavon Court,
12–16 Blackfriars Street,
Manchester M3 5BQ

A CIP catalogue record for this book is available from the British Library
ISBN 1 85754 410 2

The publisher acknowledges financial assistance from
the Arts Council of England

Printed and bound in England by SRP Ltd, Exeter

Contre-Jour

Also by Gabriel Josipovici

FICTION

The Inventory (1968)
Words (1971)
Mobius the Stripper: stories and short plays (1974)
The Present (1975)
Four Stories (1977)
Migrations (1977)
The Echo Chamber (1979)
The Air We Breathe (1981)
Conversations in Another Room (1984)

THEATRE

Mobius the Stripper (1974)
Vergil Dying (1977)

NON-FICTION

The World and the Book (1971)
The Lessons of Modernism (1977)
Writing and the Body (1982)
The Mirror of Criticism: selected reviews (1983)
(ed.) The Modern English Novel: the reader, the
 writer and the book (1975)
(ed.) Selected Essays of Maurice Blanchot (1980)

To Judith and Timothy Hyman

There is a formula that perfectly fits painting: lots of little lies for the sake of one big truth.

Pierre Bonnard

One

I had not expected to see you ever again. Yet there you were.

How funny, I thought. They haven't changed.

I rang the bell and you showed no surprise when you opened the door. I don't know what I expected. But it was as if you had known I would be coming.

We went down the corridor, you slightly in the lead, and into the room, and there he was, at his little table in the corner, reading the paper. He looked at us, his eyes bright behind the rimless glasses, and then down again at the paper, and you turned away quickly and said: 'We mustn't disturb him.' Some of his work was stacked along the walls, but as usual his room gave the impression not so much of a studio as of a corridor, a place one passed through on the way to somewhere else. I still remember vividly what he once said when I was small: 'If I had a proper studio people would expect too much of me and then I would cease to be able to do anything at all.'

We left him there and went into the kitchen. It was then that I became aware of the fact that something was missing. I looked round for the basket, the plates of food and milk on the floor, but there was nothing. I looked at you then, but as always, you were looking down and away from me. I didn't have the heart to ask.

No. That wasn't it. It went quicker than that. It was at the same moment as I realized that they had all gone, the last of the Freddys, the cats, it was at that moment, when I realized that the house was no longer inhabited by anyone except the two of you, that I realized it was no longer even inhabited by you.

And then, as is the way with these things, even the house was gone, leaving me there with nothing but the sense of your presence, of your continuing existence.

One can be jealous of a brother or a sister but I don't think one can be jealous of an animal.

I was never jealous of them. It was not because of them that you treated me as you did.

Treated is the wrong word. It is too positive. It was not because of them that I was made to feel that there was no place for me there.

On the contrary. They were part of the same problem.

Problem is the wrong word.

Part of why you held your head down as you did, never looked straight at anyone when you spoke to them. A dog or cat one speaks to with one's head bent anyway, doesn't one? So perhaps that is why they were there. You could speak to them and so avoid having to look at other people. Having to look at me.

I do not mean that you would not. I mean that even when you spoke you did not speak. Do you know what I mean?

You asked me once, on one of my rare visits, or perhaps it was in some public place, perhaps we had met at a party or a reception, by chance, and stood talking, like strangers, across the gulf of so many misunderstandings. And you said: 'Do you never think of us at all?' You didn't say 'ever', you said 'never' — 'Do you never think of us at all?' As though it was accepted by both of us, by the whole world

even, that one had to start with the negative, that it was inconceivable, even in a question, that one should start from the possibility that I actually did think of you. And I answered, as I always do on such occasions: 'Yes, sometimes.' Feeling as I said this that if only I could say what I wanted, if only my answers had not somehow been preempted by you, I would be able to say what was after all the truth: 'Always. Always. I never stop.' And this would please you. Please you so much that our relations would perhaps change once and for all. That then speech between us would become possible once again.

Or rather, would for the first time be possible.

But of course I didn't say that. What I said was just what you both dreaded my saying and were silently forcing me to say, my usual blank, defensive, 'Yes, sometimes'. As if to show you I did not need you and so spare myself the pain of your demonstrating, once again, that you had no need of me, but by that very act, of course, making certain that rejection would indeed follow.

'You sit there in the dark, brooding,' you said to me once. 'You sit in that flat looking out of the window and seeing nothing but your own reflection.'

No. You said nothing of the sort. How could you? Why should you? You never thought of me after I had gone. It was I who thought of you. Who wondered whether the same rituals were still being observed, the same rhythms, day after day. Because my own life was so lacking in rituals, I suppose, in rhythm. As though once I was alone, separated from you, there could never be such a thing as a rhythm again, only individual moments, unrelated to each other. A lot of separate moments and, between them, holes. And it was not from the day I went away that I began to feel my life like this, but from the day in the bathroom, the day I came in and found you there, in the bath and then turned and saw him sitting there, unconcerned, sketching. At least that's how it seems to me now, looking back.

Because perhaps it wasn't like that. Perhaps it all started long before. Or after. Perhaps we only imagine we deserve rhythms, once lived by rhythms, when all there ever was was moments. Separate. Distinct. Like beads on a string. Except that there is no string. Or the string has broken and the beads run about all over the floor. You go down on your knees and try to scoop them all up, but one has rolled under the bed, you stretch yourself out, grope for it, but you only succeed in sending it under even further, and then, getting up, you step on another that was behind you all the time, and hear the crunch.

Perhaps it was not guilt you felt, but anxiety. An all-pervasive anxiety which made you incapable of fulfilling your duties as wife and mother. Did you always have that guilt then or did you only acquire it later? Was it guilt because I meant nothing to you? Or simple unhappiness? The questions proliferate, without answer. Only you are real, your bent head, your abrupt way of turning, your hours in the bathroom. The rest is — what?

To return to our conversation. When you said: 'Do you never think of us at all?' and I said, as I always do, 'Yes, sometimes,' you immediately said: 'Not very often,' as though even my feelings were not my own, were known to you by right. What could I say? 'Not very often,' you said. It wasn't even couched in the form of a question any more. And that seemed to satisfy you, that 'not very often' delivered in the tones of one from whom nothing was hidden, and you turned away, had probably begun to think of something else before you had even finished speaking, our exchange had been of no importance, had hardly touched you, only confirmed you in what you had always known.

Not that the question wasn't genuine in the first place.

Just that your ability to concentrate was so limited. You darted forward, you pounced, you had to hold, to grip, to know. And then the next minute you had forgotten what it was you had not been able to do without the moment before. Is it possible to live with someone like that? Can you blame me for what I did?

You never thought of telling me whether *you* ever thought of *me*. No. It was I who had to tell. It was I who was in the dock. Was it because you took it for granted that I must know that you naturally thought of me constantly? Or because you wanted me to take that for granted? Or because it only seemed necessary for you at that moment, as at all moments, to assert that it was a daughter's duty to remember her mother? Not a mother's duty to remember her daughter.

I know what you were implying. That of course you remembered me, thought of me constantly, that that went without saying. That what you wanted was to find out whether — or not find out even, but simply bring to my attention, make me aware of the fact that I had failed you by thinking of you so little, or not at all. And then you turned away, as though, having made that point, you could pass on to something else. As though, seeing me so unexpectedly there, you had automatically homed in on the one important thing, had automatically struck at just the point where I had no answer, as though nothing else was important or germane, as though the mechanism had been set in motion which would bring to the surface, lay out before us for both of us to see, my lack of feeling, my failure as a daughter. And then, having done that, having made that point emerge, you turned away, moved on to something else, as though whatever I said could only confirm the implications of that question; however much I spoke the mere fact of asking the question made the answer spring up into the light of day and all my words, my silences, my attempts to justify myself or criticize you would only act as confirmation of

11

what you had always known: that I did not remember, or not frequently enough, or not in the right way.

Perhaps, though, that isn't fair. Perhaps you did, for a moment, wonder: has she shut us right out of her heart? Perhaps that thought even brought a momentary pain with it. My daughter. How have I lost her? Or a flicker of guilt? Was it I who lost her?

Perhaps the thought is always with you: we have done this to her and she has every right to feel towards us as she does.

And so you moved away. Darted would be a more precise description. Leaving me alone. To stare after you. To look round the room for him. I remember nothing else though. Only your question and my hesitant reply and your reply to that, and then your abrupt movement, the lowering of the head, the sudden turn, leaving me there, stranded in the middle of the room.

Now I come to think of it that characteristic movement was missing when you let me in yesterday. And the antagonism too. It was as though you were there only to let me in and lead me to him. Of course it was for him you were doing it, not for me. So that he should see me, not so that I should see him. But that does not matter. The reasons are unimportant. What is important is that I should have seen you, and him. Seen him look up, faintly puzzled, as always, from his paper. In the long low room with the big table in the centre and the canvases along the walls and him at the back, by the window, at the second, smaller table, looking up, surprised, amused, his glasses glinting as the light caught them, the tightening of his face into a faint smile. How can I put it? Utterly himself. As always.

When I see the two of you now in my mind's eye I know I had no place there. Had never any place. Even if you had not

grown strange. Taken to spending such hours in the bathroom. Shutting the door on me. Though letting him in. Him and Freddy.

I sometimes wonder whether it is memory or imagination when I see myself, a solemn little girl, open the door of the bathroom and walk stiffly up to the tub and look down and see you there, floating in the water, staring up at the ceiling. You pay no attention to me. I examine you carefully. I note the way your head emerges from the water and the way your skin shines and the soap still caught in your ears. The room is full of steam. I stand there for a long time, looking down at you, as one looks at a pool full of goldfish, watching them dart this way and that. And then turn slowly and survey the rest of the room.

I must have known he was there and yet the shock was violent, physical. He had his pad on his knee, he was leaning forward, he did not seem any more aware of me than you were. Then, when I went up and stood in front of him, he put down the pad, put down the pencil, and looked at me. I can still see myself staring up at him, and him looking at me, offering no word of explanation or apology. And then I turned and walked out. It took a long time. The room seemed to have grown so big. I knew I had to walk normally, to hide the anger and sorrow I felt, but that seemed suddenly impossible.

I had my back to him and to the bathtub. It was very silent. I had not realized that walking could be so difficult. Required so many movements. So much co-ordination. I felt I had lost the possibility in those few seconds of ever walking naturally again. Of ever doing anything naturally again. It was as if I were carrying you both inside me and that made it impossible to move a leg or an arm without revealing the strain, to hold up my head without the muscles on my neck standing out with the effort. And you behind me floating in the water, greenish in the greenish water, and him sitting in the corner, knees close together,

13

shoulders a little hunched, his pencil in his hand, and the steam rising, covering everything, making the tiles slippery, spreading a film of damp over the window-panes, the door-pane, rising up and filling the room, muffling every sound.

I cannot remember ever getting out of that room. Just the walking forward and looking down and then the sensation of someone else, someone watching, and turning slowly and the shock of seeing him, and the moments of silence, of time passing by as I stood beside him and we looked at each other, and then the turning away and walking for ever towards the door.

But that may only be my imagination. You rise up in my mind now, as I sit here, like a fish in a murky pond, and I wonder if it was the sight of you that day which settled the image inside me once and for all. You lay there, rolling slightly in the water, like a log, and though your eyes were open and you must have seen me you did not react to my presence. But perhaps you didn't see me. Perhaps it is only in my memory that your eyes were open.

Was there a dog there as well? One of the Freddys? Or was it only later that he would curl up and wait for you to finish? Curl up on a chair and go to sleep and not wake up even after you had got out of the bath and dried yourself and dressed and both of you had left the bathroom and gone about your separate tasks, that he would finally wake up, shake himself, come sleepily out and hurl himself down on the carpet in the dining-room. I have no memory of a dog there that day, only of you and of him, but most of all of myself walking forward and looking down into the tub, standing there for a long time looking at your body in the water, and then turning and walking across to him, and then turning again and walking that interminable distance to the door.

Was it from that moment that it became impossible to talk to you? Or, in effect, to him? Did something happen

then, in that room filled with steam, which made any normal relationship between us impossible? Should a word have been said then, by me, by you, by him, which, unsaid, made all speech between us impossible ever after? As though we were each locked in our different guilts, me for having surprised you like that and each of you for having been thus surprised?

My face in the pane. The lips do not move. Rain sputters against the glass but the reflection remains constant. Not easy to make out but constant. My lips do not move. As if it was not myself I was looking at but someone else. As if I had nothing to do with these words I speak to you. As if they were not spoken by me but to me or at me or in me. In my head. In my mouth. Wherever it is that words resound. In some space or place where words resound.

That figure which does not move.

Which sits at the desk in front of the window, looking. Not out and not in. Just looking. As though the act of attention freed me, allowed me to talk to you.

I do not know how long I have been here talking. Or why now and not before. As if it was important that I should speak these things. And that you should hear, once and for all. As if nothing could go forward, for you as well as for me, until you had heard.

As if, if you heard me now, the next time I called on you the dog would have returned. The cats. They would be there. Sleeping. Or eating. Or just looking.

What was it he used to say? The immobility of the cat; the motion of the dog.

I have often thought of having a dog. Cats never appealed to me so much. But how is it possible? For a dog you need a family. You need laughter and a garden and many people to

take turns walking it. One person alone should not have a dog. It puts too much of a strain on both their shoulders. One should have an animal as part of a natural way of living. It should enter the family and fit into the interstices, binding the parts together.

When you cast me out you effectively put paid to the possibility of there being any parts.

Cast out is wrong. It is too active. It suggests fire and raised swords. Since you abandoned me to myself might be better. If the word 'abandoned' could be cleansed of the pathos which inevitably accrues to it.

I wake up in the middle of the night and see myself sitting at the desk, looking out. Hear myself talking to you. As though communion with you could only take place in certain set positions.

Were you trying to shield him when you told me to go and play in the garden? Or sent me away to boarding school? Or were you only trying to give me that impression? He needed quiet for his work, you said. It would not do to have another presence in the house. As if that would have bothered him! When he worked his concentration was absolute, nothing would disturb him, and when he stopped all he wanted was to be disturbed.

I think I knew it was because of you, not him. Because you could not or would not cope with me. That was why I was dismissed.

The day after the funeral I went back. Alex offered to accompany me, knew the effect it would have on me, but I preferred to be by myself. It was quite painless. The place did not look as if it had ever been inhabited. Apart from the chair there was nothing that seemed personal. And even the chair I only took because I had always wanted a desk chair with arms. It too must have been bought in a junk-shop like

the rest, or wholesale with the other contents of some house that was being emptied out.

How can I explain the strangeness of the occasion? I said to Alex later: 'It was easy. His presence had completely evaporated.' But she didn't understand. Couldn't imagine that actually it was you who still filled that house. He had gone as lightly as he had ever existed and left no trace. He had never hoarded, there were no precious objects that had been particularly meaningful to him. There was only his daily work. And the ordinary complements to daily living, the plates, the cups, the bowls, the knives, the forks, the paints, the canvases. But even they were only precious to him because of the function they served, the food they contained, the possibility they gave him of working without interruption.

I tried to explain this to Alex but she thought I was being stoical, heroic. I never talked about it to anyone again. But now I want to talk to you about it. I want to explain to you. Perhaps because like that I will at last be able to stop explaining it to myself.

I walked through all the rooms. I went upstairs. I went out into the garden. Then I came in again and sat in the kitchen. Though he had been there, on his own, for ten years, it was your presence rather than his that dominated the place. And even that was anything but overpowering. After all, he had had time to get rid of your things, though he hardly seemed to have tried. That again was typical of him. He did not make a great sweep of your things and have them all destroyed. Nor did he preserve them preciously. He let them be, and when they got in his way he removed them.

It is impossible to think about him alone there. I can only think of the two of you. Only see the two of you in my

mind's eye. Never him alone. Or if he is alone, sitting at the little table in the big room with the light coming in through the French windows, if he is alone then your head is sure to appear suddenly round a corner, or you are to be seen, if I look again very carefully, silhouetted in the frosted glass of the door, coming in from the garden, and then the sense of you approaching becomes an inescapable part of the room.

He explained to me after the funeral, your funeral this time, when we got back to the house, he explained why he had eventually married you. 'It was not she who wanted it,' he said. 'It was I who did.' As usual there was nothing to add, or at least I could add nothing, though there were questions I wanted to ask. But with him that was never easy. At least for me. 'It was I who did,' he said, and told me how one morning it had been decided and two weeks later, done. 'So I gave her my name,' he said. In someone else's mouth it might have sounded pompous, or out of date at least, but in his it was just the way things were. 'So I gave her my name,' he said, and smiled.

It did not come as a surprise. Perhaps he had already told me, before, when I was growing up. When you were still there. 'Then we decided to put an end to it,' he said. 'I gave her my name.' It was as though he were telling me a story about far-off days, about ogres and fairies or Sinbad the Sailor. I could only nod. I sat on one knee and one of the Freddys on the other. He stroked our heads in turn and it was perhaps to both of us that he spoke: 'You must be patient with your mother,' he said. 'She is not well these days.' And you for your part would take me aside and say: 'You must be patient with your father. His work is not going well.'

The house was yours. It belonged to the two of you. I sensed that from the start. The garden was mine as well, but the house was yours. The dogs and cats were welcome but I was an intruder. Only in the garden would he throw me up and catch me, would he bend down and examine the

flowers with me and tell me all about them. While you hid behind the washing and listened.

Don't be angry with me. I looked for you in the garden but you hid from me. As if it was not possible for the three of us to be together. I knew you were behind the sheets, but I was afraid to look. And when I finally did you were hurrying up the steps to the veranda. 'There's so much to do,' you used to say. 'So much to do in a house this size, and your father needs so much looking after.'

What did you do all day in that house when I was no longer there? What are you doing there now? I suppose the answer is that you did all the things people do, nothing special, nothing out of the ordinary, just the things people do when they live. You ate and you fed the animals — may I ask you why you always had dachshunds and why you called each one Freddy? Did you not feel there was something insulting to them in calling each one by the same name? As though they had no individual traits at all? I have never dared to ask before, you both took it so much for granted that that was how it had to be that I felt I must have missed something to be puzzled by it and never dared ask — but that was typical of my whole relationship to the two of you. And, to go on with my list of the things you did, you sat and looked out of the window or down at the carpet or just out into space. And he sketched and drew and painted, sitting on the edge of his chair, the glasses poised on the tip of his nose, the little moustache bristling, a slight smile on his face. Or he stood facing the canvas in his studio that wasn't a studio and every now and again approached it and made a mark and then stood back and looked. He walked in the garden too and out on to the hills above the house, and looked out across the valley to the sea. But most of the time he sat inside, by the window, looking out, or looking in, into the room, and looked, and drew. 'Other artists need a studio,' he would say. 'It would inhibit me to have one. I would feel, each time I went in there, that I had to justify it,

19

justify myself, that I had to paint a real painting, and then I would panic and not know what that was and not be able to do anything at all. But what I want to paint,' he would say, 'what excites me as I sit or walk, is the way things are seen out of the corner of the eye, are felt at the edges of consciousness. Art in the West has for too long been the victim of a mad idea, the idea that objects and people face you squarely, that you have all the time in the world to gaze at them. But life isn't like that. It slips by. There is light, there is movement, like the dog entering the room while I look out at the mimosa.'

So he would sit and sketch, or stand up close to the canvas pinned on the wall of that room that wasn't a studio, that was hardly a room, more a corridor through which everyone passed, although you would say ten times a day: 'Don't disturb your father. He is working. Don't disturb him.'

What he wanted though — and this was the remarkable thing about it — was not to catch this sense of movement with a sketch, but monumentally, with paintings as big as any painted by the great masters of the past. 'If art is worth anything at all it must be this,' he would say, 'that it does not deny time, it makes it palpable. I want my people to be bathed in time as the Impressionists bathed them in light.'

He rarely spoke about these things, to me at any rate, and to you too I suspect. He did not speak much at the best of times, and when he did it was not often about art. In the early days, perhaps, to friends who came to see the work or to collectors who came to buy. Which he did not like. He would shut himself up for hours before such visits, and, when the bell rang, he would be seized by the need to rush to the lavatory and would only emerge much later, leaving you to deal with the visitors. Which you did surprisingly well. Perhaps it was an effort, but perhaps it also appealed to you. To the actress in you. Though no doubt you found it a strain. And in the last years, when he would have liked to see his friends occasionally, it was you who held him back,

who made all that impossible. That was when the compulsion redoubled. When you spent more than half the day in the bathroom or sat crying on the bed in your slip, saying you had no clean clothes to wear, that you could not go out, that you would shame him if you did, that he was trying to force you to do something he knew you hated.

At first he would stand there, by the bed, silently waiting, forcing you to pull yourself together by the sheer strength of his presence. But even though you would succumb at the end of such sessions it was you who won out in the long run. He preferred to forego the pleasure of seeing his friends and be spared these exhausting battles of the will.

And what were you fighting against? Why were you fighting? Was it that you wanted to have him to yourself? You weren't satisfied with having driven me out but wanted to drive away all his friends as well? Or was it that you genuinely grew frightened as you grew older at the thought of facing other people? Or was it some combination of the two, the one feeding the other, though which was the deeper cause, the primal reason, you probably never knew yourself.

Perhaps you were right to want to protect him. Perhaps he only achieved what he did because you protected him so single-mindedly. Against his children. His friends. Even himself. As if you were his conscience, his superego. As well as being the feminine presence he needed around him. At the edge of his consciousness. Someone who would always be there. Who always was there. Yet not intrusive. Going about your business. Cooking. Or laying the table. Or hanging out the washing. Sitting or lying in one of the deck-chairs that stood about not only in the garden but all over the house. Yes, now I think about it, that is something

else I wanted to ask you about, why it was that there were so few ordinary armchairs and sofas about the house but masses of these canvas deck chairs instead? Did you find them more comfortable? Or were they cheaper? Or just easier to buy?

Anyway, you lay about in them and dreamed. Or played with the cat. While he worked. Filled with your presence. Filled with the sense of you, of life going on about him as he worked.

And it has to be said, you did not ask for much. You made no great demands on him. You were as little concerned as he was with fine clothes or beautiful furniture or visits to the hairdresser. In that sense your two lives were perfectly attuned. In fact it has to be said you were both remarkably self-sufficient. Perhaps that is why you had so little under-standing of those who had need of others, especially those who might have needed you.

But having said that I have to say also that this self-sufficiency was not entirely unpathological. The way you bent your head, looked down and away when you were in a room with anyone else, even with him, the way you darted off as suddenly as you had arrived, above all the hours and hours you spent in the bathroom, rubbing, scrubbing, scraping, cleaning, washing away that imaginary dirt — that was the other side of the self-sufficiency, was it not? That was more akin to a despair which could find no way of communicating with others, which turned in on itself and gnawed at its own heart. He may at first have tried to help you. Have tried to talk to you or get you to talk to him. But I remember only the silence, the sense of helplessness and hopelessness as each of you sat in a different corner of the room, turned inwards, or turned away at any rate one from the other, yet anything but indifferent, the sense that some-thing had to be done but able only to go to and fro between you, helpless, as silent as you both were.

I don't know when he gave up. I don't know if he ever

did. Sometimes I think you understood each other well. As well as it is ever given to any two human beings to understand each other. That it was only I who was excluded. That your absence from each other was only the result of a deeper sense of one another's presence. He was not much present to anyone else. Not remote exactly, but reserved, ironical, as if he knew the limitations of communication, of expression, and rather enjoyed them. That was the source of his strength. In his art as well as in his life. 'I have nothing to say,' he told me once. 'I have nothing to impose on the world. And I don't even believe the next stroke will take place, let alone the next picture be finished. Or even begun. Yet I am drawn to work. I can't stop. And somewhere I suppose I believe in it. I believe at any rate in the daily confrontation with my own inadequacy. When I'm not sketching or painting I have a feeling of suffocation,' he said. 'As though the lies on which all existence is based, the compromises and hesitations, were being condoned. That is the point,' he said to me in one of the few bursts of speech I remember from him. 'That is the point. That when I have a pencil or brush in my hand I feel I am confronting the lies, but the rest of the time I am simply living them.' I didn't know what he meant but I think that instinctively I understood. That is why I sit here now and look out of the window, or look at the reflection of the room in the window, at the blur of my face, and talk to you as I am doing, in silence, inside my head. Because the need to talk has always been there and even if what I now say is false it is something, it is a way of finding the truth, my truth. Otherwise I sense the weight of your presence, your absence, gathering on my neck and I know that in a little while I will no longer be able to bear it.

No. That is false. I will always be able to bear it. I would like not to be able to bear it. I would like my neck to be broken by it, then I would know 'it' was something real, not a ghost conjured up by me. But I know too that that will

23

never happen. My neck will not be broken, but there will come a time when 'it' will become so overwhelming that I will never again be able to call myself myself, never again be able to turn these matters over in my mind. So I talk to you. Do you understand? Look at me. Don't turn away. Look at me just this once.

It doesn't matter. I can talk even if you don't want to listen. Even if you turn away your head or bend down and feed something to the dog, hiding your head behind the table. When you straighten again I will be there. I will not have gone away. I will still be talking. I will not have grown silent.

I see you both in the mirror of my mind. You are seated at the table with the dog on your lap. There is a bottle in front of you and you have on your red blouse with the black stripes. As usual your head is bent as though you were talking to the dog or feeding him something. But it does not seem that you are actually doing either. Behind you the door is open, and next to it the window. The garden is in flower. In the mirror there is only a profusion of colours and the blue of the sky.

He sits at the little table in the corner, sketching. The only noise is the sound of his pencil as it covers the sheet of paper. Every so often he rubs out what he has just done, gently, thoughtfully. He does not use a rubber as other people do, with violence, but as though it were an extension of his thought, as though his hand, as it rubbed, were feeling its way towards what would take the place of that which was disappearing.

There is no violence about him at all.

In the mornings he goes for a walk. He needs to sort out in his head just how the parts of his current painting are

going to relate to each other. He needs to move the different elements about in his mind's eye, to set them one against the other or space them out a little more, to move a chair back into shadow or bring a leg into prominence. For that walking is essential. There is the work of the hand, he says, but it is only an extension of the body. It is necessary to feel in your whole body how a picture is shaping up. When he is happy he says: 'There is all the time in the world. I walk a little and sit a little and then I come home and touch it a little. It is less like creating something than like feeding a big animal.'

'If you don't walk you grow dizzy,' he says. 'There are so many possibilities. But also: the animal must be fed daily or it withers and dies.'

The mirror in my mind is at an angle to the room. There are parts of the room I do not see. But the frame makes me focus harder on what is visible.

Why did you turn on me like that? The house was large enough for all of us, was it not?

As I say this though, I see that it had nothing to do with size. You simply did not know how to cope with a child. That is all there was to it. When I came to you with my arm bleeding you fainted. When I asked if I could have friends round to play you sulked. When he looked at me in your presence and said: 'Your clothes are torn,' you burst into tears. So it was he who took me into the village and bought me another dress. When we got back you were nowhere to be seen. Of course he left me on the threshold and went out into the garden in search of you. Of course he found you. Of course when you both came back you had monopolised all his attention. And the next time he said: 'Hasn't she got any other clothes?' and looked at you you turned your head away and he did not press you any further, simply turned back to his work and once again became absorbed in it.

I never asked for much. Only the minimum. And as I said to you once, I didn't ask to be born.

No. I take that back. Why say things like that? As if there were not enough banalities in our lives which we could do nothing about? Why add to them? The truth is you could not help what you did. Did you want to be unnatural? Did you want to spend your days in the bath, washing, scrubbing, never satisfied till you had removed every last trace of dirt — in other words never ever satisfied?

You couldn't help it. You didn't want to become what you were. You had perhaps envisaged quite a different life for yourself. But what I felt from the start was how passive you were, how you drifted through life without protest though inside you everything was protesting. But you could not utter it. Only grow more pig-headed in your unhappiness. Turn your head away when someone spoke to you. When he reproached you. So that after a while he ceased to do so, looked at you with those twinkling eyes, curiously, yet with pity. And never ceased to paint you. And you let him. Pretended not to notice. Or perhaps, after a while, didn't.

Once, I remember, when he was about to photograph you, you turned on him suddenly and said: 'Will you never stop? Not even when I'm on my death-bed?' But then, when you saw what an effect your words had upon him, you burst into tears. And he stayed like that, with the camera in his hands, looking down at the ground. I touched his hand. He didn't move. I tugged at his jacket and he sat down, but like a sleep-walker he almost missed his chair, didn't try to adjust himself upon it, laid the camera on the floor at his feet, picked me up and put me on his lap. I pressed my face into his jacket and he stroked my head, but I felt he was not really there, that he was still turning your words over in his mind, still looking at you as you sat with your head on your arms and your arms on the table, sobbing, violently at first, then more spasmodically, so that it seemed to be easing gradually but actually went on for a long time. A long long time.

26

It was as if you didn't want me to grow. Or didn't want to know me. I was pushed into a corner and made to watch while the two of you carried on with your lives together. So that when I left I felt for the first time that I could breathe. I had not realized it before but in your presence I was stifling. Yet what good would breathing do me? It was as if now that I finally could there was no longer any point in doing so. That is why, when you asked me, as you occasionally did, what I was up to, I had no answer. The very form of your question smelt of indifference. Before such words what could I be expected to answer? Nothing, would have been the reply I would readily have spoken, but instead, of course, I merely said: 'Oh, this and that,' and, as if that was a sufficient explanation, a full and entirely satisfactory explanation, you would say: 'Good, good', and hurry away, or wait, holding the phone, in that maddening way you had, so that one wondered why you had bothered to ring in the first place. And when I asked you that, point-blank, when once I said to you, as I remember I did, 'Why do you phone if you are not going to say anything?' you replied: 'But I wanted to know how you were', and then again that silence, until I could do nothing but slam down the phone in disgust. Which led of course to his ringing me himself and asking me why I persisted in being rude to you, what it was I had against you, why I cut you off so rudely when you had rung up to ask after me. 'There is no need to be rude,' he said reproachfully, as if that were the issue. 'There is never any need for rudeness, you know.' And I wanted to speak to him, to tell him everything, to explain about the silences and what they implied and ask him why he put up with you and why you persisted in acting towards me as you did, but how can one say such things on the phone? Especially when I could never have said them to him face to face.

I think you were both of you to blame. I think it is no excuse to retreat behind one's sketchbook. He left you to take the decisions but that hardly absolves him. When I said

27

to him: 'Do I have to go away?' he looked up and gazed at me with those inquisitive brown eyes of his and said gently: 'It's for your own good. It's a much better school you know.' And when I burst into tears he stroked my head and said: 'You'll see. In later life you'll thank us for having made this decision.'

Perhaps you did what you thought best. But couldn't you see that I would feel it as a rejection? That I would never be able to trust either of you again?

Is that right? I wonder now if perhaps I lost confidence in you that day in the bathroom, long before you sent me away to school. Or even if it was not that, coming into the bathroom that day by accident and seeing you there and then turning and becoming aware of him, if that did not simply make me aware of something I had known all along, known from the moment I was born perhaps, that there was no place for me with the two of you and that there never would be.

And do you know what that made me feel? Not just that I was not wanted, but that *I did not exist*. I had never existed and I would never exist. So that now as I sit here and talk to you it does not seem to me that I have a past at all and I am certain I have no future. My past is you, that which I did not have, your relationship, your possession of that house, your clothes and your baths and your garden and even your animals. They belonged to the two of you and I could only look on, look in. But not from a world of my own. Only from the shadows, a shadow. Which is why I could never speak to you, or to him, and why even now I cannot speak, not really, can only put together a few half-formed sentences or, if they are more than that then they are banalities, clichés, the things everybody says and not what I want to say, not the expression of what I alone feel and want you to know.

Did you know that I had been back? Did you know that I had sat on the hill and looked down at the house? Seen the

smoke rise from the chimney and sat and waited for the inhabitants to emerge, but though I heard voices I never saw them. I wondered about ringing the bell, making myself known to them, asking to be allowed to look round, but the thought of having to do that with other people around, people I had never met before, was too much for me.

The house was different from what I remembered. Smaller. More obviously one house among many, one garden among many. Whereas in my memory it is unique, incomparable, the entire world. I even wondered if I had the right house, but yes, that was it, there was no denying it.

I went back to the village then and sat in the square and had a drink. The plane trees were in full leaf. It's funny, I remembered climbing up to the village from the house, but there I was, going down to it. I wonder why memory plays those tricks on us.

It is so quiet here. It seems to have been unnaturally quiet for a long time. Since you both left me, I suppose. Or perhaps since I left you. Though it was you I fought and still fight, it was always a fight to win you over to me, not a fight to destroy you. Did you know that? Perhaps I didn't myself, it was only when you left me that I realized it.

As soon as I heard I went down to see him. He opened the door and let me in. We said nothing. I walked ahead down the corridor. He was stooped, thinner than I remembered, but the eyes were still quizzical behind the rimless glasses.

I went ahead of him down the corridor as though I knew where I was going. We found ourselves in the kitchen. The place was as clean and as untidy as it had always been. I went round the table and sat with my back to the window. He sat down opposite me. I didn't know what to say, and as usual

he was not going to be the first to speak. Finally I said, more to hear a voice than for any other reason:

'Are you all right?'

'Of course,' he said.

'Is anyone looking after you?'

'Alex is here. Till things calm down a bit.'

He went on looking at me in that way he had. I always felt when he did that as I feel when a customs official looks you in the eye and asks if you know the law and do you have anything to declare and you invariably feel guilty. Except that with him there was no sense of fear at being found out, simply the sense that he could see into you much more clearly than you could yourself.

I said: 'Was it . . . peaceful?'

'Fairly,' he said.

He didn't elaborate. I waited. The window was open and the french window too, and it was as if the garden were inside the room. As if we were just a tiny part of the outside world, but a real part, bathed in its light as we would soon be bathed in its darkness.

I wanted him to give some explanation. To apologize. To say something about you. But all he said was: 'Do you want to look round?'

'Later,' I said.

We sat in silence. Then he said: 'And you?'

'Me?'

'You're . . . making out?'

'Of course,' I said.

He kept looking at me. It became a question of hiding from him all that I felt. Of keeping my face impassive, so that he would not see the emotions that were whirling about inside me.

Of course he would win any battle of silences. In the end I said: 'What about Freddy?'

'He died last year.'

'You didn't get another?'

'No.'

I suddenly felt very sorry for him. Though there was no reason why he should not get another, as they always had, one dachs after another, Frederick the First, the Second, the Third, the Fourth.

He was waiting. I said: 'Is there anything I can do?'

He smiled and shook his head: 'No.'

He didn't ask. 'Like what?' Or say thank you. Just: 'No.'

I suddenly said: 'May I look round now?'

'You want me to come with you?'

'No,' I said. 'I'd rather be by myself.'

I stood up. He went on fixing me with his sharp eyes. I went round the table and past him and he didn't move.

When I came down again he was still there, in the same position. He had a cat on his lap. I should have known he would never be entirely without animals.

I went out into the garden. The house had meant nothing to me. I didn't know what I had expected, but the house was dead to me. Not the garden though. I couldn't bear it. I went back inside. I sat down at the table facing him again.

'How many years was it?' I asked him.

'Fifty,' he said. 'Just about.'

'And now?'

'Now?'

This time I waited for him. He shrugged. He held his hands out in front of him, palms down, in that characteristic gesture.

I realized then it was you I wanted to talk to, not him.

Why did you thrust me away?

Why did you hack at my roots and then throw me out?

I suddenly said to him: 'Why did you act towards me as you did?'

'Me?' he asked.

'Both of you,' I said.

He was silent again.

'Why?' I said.

31

He shook his head.

'Tell me,' I pressed him.

He got up and went to the window. I waited for him to speak, but he didn't. I sensed him standing there but I wouldn't let him go. Then finally he moved again and went out into the garden.

I watched him walk down the path and disappear among the trees.

I waited.

Evening came.

I got up and went out into the garden. One of the cats was suddenly there at my heels.

He was sitting under the willow by the pond. I stood by the bench till he looked up. Then I said: 'I'll have to be going.'

'Yes,' he said.

I turned away. The cat ran across the path in front of me and disappeared into the bushes. I didn't want to look back.

I went through the house and out, then round to the bus-stop at the edge of the town.

I don't know what I had expected, but it wasn't what had happened.

I didn't feel as I had expected to feel.

Do you understand? It was you I had wanted to talk to, not him. And yet now, strangely, I knew I would in fact be able to talk to you. I had only to get back home. To get back to my chair and my desk. Get back to the window. There was plenty of time. I knew that I would have all the long summer evenings and nights in which to talk to you, as I am doing now.

As though with your death he had become irrelevant. I wonder why.

Will you try to understand me? I don't ask for much. I only want to know why you always behaved towards me as you did. No one would have called it natural. Or would they? I know I was difficult. I know I may have been too demanding. But no one would have called what you did to me natural.

For a long time I was too unhappy to do anything. Too unhappy to want to think about what had happened, far less talk about it. Now it's different. Now I have to. Before it's too late. We have to talk before it's too late. I owe it to you as well as to myself.

Does that make any sense at all? To talk to you now and say I owe it to you? Somehow it does. I don't know why but it does.

One does not bring someone into the world without feeling at least a shred of responsibility towards that person. And if that responsibility is denied one cannot help but feel guilty.

It is to relieve you of your guilt that I have to talk to you. It is to make us both free, of each other and of ourselves. I want you to know that I am well. That I have survived. That I will always survive. But also that you have hurt me. I want you to acknowledge that what you did was inhuman. Understandable but inhuman. I want you to acknowledge that for your sake and mine.

I know what you will say. You will say that I was always too demanding. You will say that I was unreasonable from the start. Not just with you but with him as well. With both of you. That I made unreasonable demands on you both. That if my demands had been reasonable they would have been met. But why were my demands unreasonable? Because they could never be met? Why were they unreasonable? Because I sensed from the start that to you whatever demands I made, however reasonable, would always seem excessive? Even this you will find just another example of such excess. Why can't she leave us in peace?

you will say. Why does she have to ruin everything by overdoing it again? You will say that if I had not spoken as I have now all would have been well. That we would have found our way to each other again. But that by speaking out like this I have made reconciliation impossible.

That was how it always was. If I kept quiet I was forgotten. When I made my presence felt I made it felt in the wrong way. But don't you see that every way is the wrong way as far as you are concerned? Don't you see that if what you say is true then there can never be any hope for us at all?

I beg you to think about all this. I beg you to reflect on it quietly, not dismiss it out of hand. Go and sit down on the veranda and reflect on what I have just said. Think about it again when you have got into bed and switched off the light. Do not simply dismiss it from your mind.

I know that instructions of this sort are just what most annoys you. I know that if I had not said this there would have been just the chance that you would have done what I asked, but that now there is no chance at all. On the other hand there was never any chance, so I suppose it was best to make my case in as clear and honest a way as I could.

I know you have always tried to protect him. But don't you think that in that way you have perhaps destroyed him? Have perhaps stifled him? After all, it is because of you that he gradually isolated himself. It is because of you that his friends gradually detached themselves. It is because of you that everyone, his own daughter included, has become estranged from him.

You buried him alive. Do you realize that? He needs peace and quiet, you said. For his own good. For the good of his work. But was it not because you could not bear to share him with anyone? Even for a portion of the day? Do you not realize how selfish you have always been and how much you are responsible for?

Perhaps I do you an injustice. I know you could not help what you did. I know you hated yourself for acting as you

did. I know you often said you were destroying him and it would be best if you simply disappeared, or died. I know you meant what you said. But you knew that he would never let you go, and it would have been more honest, really, to have recognized that and tried to act a little differently in the daily course of things.

But I suppose you could not help it. You were driven. Something stronger than you made you act as you did. Help me, you seemed to be saying. Help me against myself. But how could he help you? No one can help another in circumstances like those. Do you understand what it was you were saying? 'Help me to stop myself destroying you, can't you see it's killing me?' Was there ever a more impossible cry for help?

Am I putting words into your mouth? Am I projecting my own feelings on to you? Perhaps. But I must take the chance. I feel that these things must be said. They cannot be allowed to remain buried in silence for ever. There is not much time left. If they are not said now they never will be. Believe me. I want to help you. Selfishly, of course. Because in helping you I hope to help myself.

That is the kind of thing I might say to you, if I were to write to you. If there were still time to write. Perhaps it is the kind of thing which I did write but to which you never bothered to reply. I no longer remember. It no longer matters. Though if you had replied I would not be sitting here, repeating the same old things, letting the world grow dark around me.

Perhaps though I never wrote them. How could I? You had robbed me of the possibility of speech. That is the real irony. You gave me life yet robbed me of that which gives meaning to life.

Is that a vain accusation? The kind that all children, at some time in their lives, level at their parents? You gave me life yet robbed me of the possibility of living.

But perhaps like all children I am asking for too much. Perhaps that is the very condition of speech, that it finds itself to be impossible. So that the perpetual feeling which children have that they cannot speak is not the fault of parents at all but simply one of the conditions of our world.

I can say that but I can't quite believe it. Or rather I can believe it but that does not free me from that feeling of rage towards you for having done what you did to me.

I remember when I tried to phone you. There was a silence. I called the operator. He said he would make enquiries and call me back. And did. To tell me the phone had been disconnected. 'But is anyone still living there?' I asked. 'That I wouldn't know,' he said. 'You should make other enquiries.'

What enquiries does one make? It is true I had been away for some time. I had been travelling far and wide. But my letters were not returned. They simply remained unanswered. If there had been no one there or if there had been new owners the letters would have come back. I wrote my name and address carefully on the backs of the envelopes. They would have been returned with 'not known at this address' scrawled over them. The fact that they did not come back meant that someone was receiving them and simply not bothering to answer.

That was when I decided to come down and see you. I knew you wouldn't like it. I knew if you were still there you would resent my barging in like that. I knew you would feel that though a possible reconciliation had perhaps been under way my arriving like that, uninvited, pushed back such a possibility until it stood hardly any chance of success. But that is how it always was between us.

So I came down.

I don't know what I had imagined. Of course I had

moved you both about in the house in my mind many times. Stood or sat you in this room or that, together and alone. I don't know what I was expecting. Perhaps that he would be alone. Or that you would both be together. But not that I would find you alone, dozing on your deck chair with the cat lying across your breast and the sun on your face and him nowhere to be seen.

Had you been expecting me? Had you known deep down that I would come? Had you perhaps not answered the letters precisely because you knew that in that way you would eventually force me to come? That if you had written and begged me to come I would of course have refused?

At any rate you did not seem surprised. The cat jumped off and disappeared. You did not move, did not ask me to sit down or apologize for not having come to meet me at the door. Just waited, eyes open, looking up at me.

Do you remember?

I sat down. You said, finally: 'This is unexpected.' I could not tell from your voice whether you were pleased or appalled.

'Is he here?' I asked.

You gestured vaguely in the direction of the outside.

'With the dog?'

'Uhuh,' you said.

'How is he?'

'How is he?'

I nodded.

'Well,' you said. 'Working very hard. Doing wonderful things.'

As always you seemed embarrassed by my presence. You kept turning your head to the french window in the hope of seeing his silhouette appear, rubbing your hands together, looking down at the floor.

I waited, watching you. Finally you said: 'Well?'

I smiled at you. I felt happy to be there. But my smile

only seemed to make you more nervous. You got up and went to the window.

'He should be back by now,' you said.

'I don't mind.'

You stood there, rubbing your hands together, turning your back to me.

'I tried to phone,' I said.

'Oh?' you said.

'It's been disconnected.'

'Oh,' you said. 'Yes.'

You turned back to face the room, but you didn't look at me.

'Why?' I said.

'Why?'

'Why was the phone disconnected?'

'Oh, he prefers it like that. There were too many distractions.'

'You didn't answer my letters.'

'Didn't I?'

I waited.

'You've come for a particular reason?' you asked eventually.

'Reason?'

'You don't call on us that often.'

'No,' I said.

'Is it that you're getting married or something?'

I burst out laughing.

'Is that funny?' you said.

'You don't know how funny it is,' I said.

'Why?'

'Why?'

You pounced on a cat that had come into the room. Not the one who had been there before. Tabby. Then settled back into the deck chair. With the cat on your lap you suddenly seemed more at ease.

I waited.

'It's the sort of reason for which children usually come back to see their parents, isn't it?'

I always forgot. You had lived with him all those years, with the most unconventional of men, you had lived together for eighteen years before you married, and yet you were still locked into the little bourgeois world in which you had been brought up.

'You think that's the only reason I should come and see you?'

You seemed to have forgotten me. You bent over and tickled the cat's neck and whispered to it. At times I could only see the top of your head above the table. Your hair was drier but it still had some of its old colour, its old red glow I always envied so much.

I don't have the words for what I felt then, seeing you bending over like that and whispering to the cat.

'I thought, when I saw you,' you said, looking up, forcing yourself to look at me.

'You thought I had come to announce my pending marriage?'

You were silent.

'No,' I said.

How could I explain to you that such things were out of the question? That to marry one had to be someone. You can't marry if you're a ghost. You have made me into a ghost, I said. But my lips didn't move.

'Ah well,' you said.

You waited for me to explain why I was there. But how could I? I didn't know myself.

I think we were both waiting for him.

I said: 'And you? Are you well?'

'Me?'

'Yes. You.'

'You're not interested in how I am.'

Not a question. A statement.

'Why do you say that?'

'You aren't.'

You had taken out a handkerchief and were wiping at a spot on your blouse, up by the left shoulder.

'That's not for you to say,' I said.

You seemed to have forgotten me. I watched, fascinated, as you rubbed away at a spot I couldn't see. You grew excited, angry, twisted about in your chair, the cat jumped off your lap but now you didn't even notice it.

'Damn!' you said.

I watched you.

'Oh!' you said. 'Oh!'

And rubbed.

'This blouse is filthy!' you said. 'I must go and change.'

'I don't see anything,' I said.

'Filthy!' you said, rubbing away at it. 'Filthy!'

You stood up. 'Excuse me,' you said. 'I don't know how it got so filthy. I must go and change. Excuse me.'

You didn't look at me as you rushed out of the room.

I sat, waiting.

It was very quiet. I could hear the water gurgle in the pipes now, and the sound of a bath filling. And with that sound, unexpectedly, it all came back, all my years here and all that had passed between us, between the three of us, here, within the confines of these four walls.

I looked up. I must have heard another sound. I don't know how long I had been like that, taken back into the past by those sounds of water in the pipes. But I looked up suddenly and there he was, behind the french window, in the garden. I don't know if he could see me as I could him, or how long he had been there, watching me, if that was what he was doing. But then the door opened and he entered.

Perhaps he hadn't seen me. He stopped, with his hand still on the handle, and stared at me from behind those little round rimless glasses of his.

We looked at each other.

Then he came in, closing the door behind him.

'Hullo,' I said.

He smiled. When he did so I realized that you had not smiled once during all the time we had been together. Not even when you were talking to the cat on your lap.

'You've seen her?' he asked.

I nodded.

'She's . . .?'

'There was a spot on her blouse,' I said.

He nodded and sat down. Not in the chair you had vacated but an upright one, at the table, from where he could look out of the window into the garden.

'Soon the mimosa will be in flower,' he said.

I nodded.

'You should see it. It fills the room. It fills it.'

I waited, watching him.

'You've been out into the garden?'

There was a scratching at the door. He got up and opened it and a dachshund walked in.

'That can't be . . .?'

'No, no. From the same breeders though.'

'Freddy?'

'The Sixth.'

He sat down again. He seemed lost in thought.

'No,' I said. 'She didn't . . . show it to me.'

'Ah,' he said. 'You should see. In the spring. The almond tree.'

'I've come at the wrong time,' I said.

'Oh no,' he said. 'There are wonderful things out at the moment. Do you want to have a look?'

He didn't move though, and I sat still. He got up and washed the plates out of which the dog had been eating and drinking, then filled them again, carefully, a plate of meat and a bowl of water. Before they were even down the dog was eating.

He came round the table and sat down once more.

41

We both listened to the sounds of the dog eating, the water gurgling in the pipes.

Finally he said: 'You're staying a while?'

'No,' I said. 'I must get back today.'

He said nothing. I caught his eye and he smiled.

'Is she . . .?'

He shrugged.

I wanted to ask but I felt he didn't really wish me to.

'Will you show me what you've been doing?' I said.

'Me?'

'Who then?'

He laughed. 'I'd rather show you the garden.'

So he showed me the garden. And when we came back into the house you were sitting in the deck chair as you had been when I first arrived. One might have thought you had never moved.

I see you both there in that room as you were when I left you. I think of you both as still in those precise positions, you dreaming in the canvas deck chair and him sitting very upright, his glasses glinting, his eyes darting up at you and back to the paper, the stub of pencil hardly protruding from his hand, another finger. The only sound is that of the pencil on the paper. Scratch scratch scratch. Scratch scratch scratch.

I had no place there. I was only a visitor. Not unwelcome, that would have been too strong. Barely noticed. Hardly there at all. And that is how it had always been. Neither of you really ever knew what to do with me. Your lives were closed to anyone but yourselves. And of course I was never an easy child. Because I felt so completely shut out of both your lives I only clung to you more closely, and this in turn only made you more determined to keep me out, more resolute in your deafness to my appeals.

Perhaps it wasn't really like that though. Perhaps it was always only my fault. Perhaps I merely overreacted to a common complaint, to what they call a fact of life. Perhaps

none of it happened as I so vividly remember it, perhaps there was never any sense on your part of wanting to be rid of me, only my inordinate desire for more love than anyone could be expected to give, even to their child, and then my guilt at sensing that I was asking for more than you could give. Or perhaps the guilt had to do with my wanting to escape you both, which I tried to assuage by inventing this story of your rejection of me. I don't know. We act and then we try to interpret those acts, but the interpretations are only perhaps further acts, which themselves call out for later interpretation. Whatever the truth of the matter is, that day, like all the other days I ever passed in your company, I felt as if I was not wanted and did not belong. As if you barely noticed me when I was there and would forget me the moment I was gone.

I said to you, when he went out of the room: 'It's hope-less, isn't it?'

'What are you talking about?' you said, jerking your head round to face me, then quickly looking down at the floor.

'My coming,' I said.

'I don't know what you mean,' you said.

Since you wouldn't talk about it what could I say? I tried with him when he saw me out.

I sat in silence for a long time, looking out of the window and listening in a half-conscious way to the sound of his pencil. Finally I said:

'I'm going now.'

'Already?' He looked up from his work.

'Yes,' I said. 'I've got to get back.'

'Ah well,' he said.

He put down the pencil and pad and stood up.

'Don't bother,' I said. 'I'll let myself out.'

But he was already standing at the door, waiting. I bent and kissed you quickly but you hardly reacted, put a hand up towards my cheek and then let it drop.

He was standing in the entrance hall.

'Isn't it?' I said.

'What?'

'Hopeless.'

'Your mother?'

'My coming,' I said.

'Oh?'

I could see he was unhappy, did not want to be where he was. But I couldn't let him go as easily as I had you. 'Pointless,' I said.

'Oh,' he said. 'You want a point.'

'Yes,' I said.

He stood, waiting for me to go. I suppose he felt he couldn't make the first move, hand me my coat, open the door, it would be too much like driving me out.

Finally he said: 'Why?'

'I need it,' I said.

'If you knew,' he said.

I think I understand now what he meant. Sometimes I think I understand. But then I think: you made me what I am. You are responsible. If I feel that way it has everything to do with you. With what you gave me. With what you withheld.

That is what I reproach you for. Not accepting that it is you who are responsible. Turning your head away from me. I know I was not the only one. You turned your head from the whole world. But the world is something else. It can look after itself. Your own child is different.

Don't think I do not understand. Who wants that kind of responsibility? Perhaps you didn't feel you deserved it, or simply didn't feel you could cope. You hoped that if you turned your head away this thing you did not know what to do with would simply disappear. And when it didn't you could not forgive it.

But if it wasn't your fault was it mine?

There are things I don't want to remember.

There are things I don't want to say.

44

Enough. I have said enough.

I can imagine a time when *I* was not there. When there were
just the two of you. But a time when you were not I cannot
imagine. Even a time when you existed but not together.
For me you are always together and always in that house.
Though of course you did inhabit others and even with me.
But it is the sense of that last house in the hills above the sea
which stays with me. From the beginning it was yours, the
one in which you lived, the one in which I came to know
you. Of course he had a knack of working anywhere, even
in hotel rooms. I remember your telling me with pride: 'He
didn't stop working, though we were never in the same
hotel for more than a week at a time.' That was the first
holiday you took together, in Normandy and Brittany.
'Wherever he was became his, he made use of whatever lay
to hand,' you said. He pinned his unstretched canvases to
the walls, mixed his colours and set to work. Sometimes he
painted two or even three pictures on the same piece of
canvas, with only the faintest margin between them. 'A
writer doesn't know how long his book is going to be when
he starts,' he said once, 'so why should a painter be expected
to know the size of his picture?'
 But with you it was different. You needed to get to know
a place before you could trust it, to stump across it this way
and that for a long time before you felt at home in it. If you
can ever be said to have felt at home anywhere.
 Of course at first you fitted in. Were unobtrusive.
Always on hand. It was only as the years went by, in this
house, that you grew odder, took to washing more and
more frequently, until you practically lived in the bath-
room, refused to leave the house, to see visitors, to speak to
anyone. 'Leave your mother alone,' I remember he said to

me one day. That was when I realized that something was wrong. You lay on the bed with your face to the wall. I was pulling at you, trying to get you to turn round. 'Leave your mother alone,' he said. I paid no attention. I think it frightened me to see you like that with your face to the wall, completely motionless. He picked me up then, carried me out of the room. I began to howl. You did not move. I could still see you, over his shoulders, an inert bundle on the bed, as he closed the door.

'Quiet,' he said, 'quiet. Your mother is not well.'

'What's the matter with her?' I said. I think I felt it was unfair, that you were behaving unfairly, that you were doing something that was not allowed.

'Come,' he said, putting me down. 'Let's go out and take a walk.'

'I want mummy,' I cried.

'She's not well,' he said. 'We must leave her alone for a while.'

'What's the matter with her?'

'She's unhappy.'

He would never talk down to one. Even to a child. Or try to protect one. As he never tried to protect himself. I remember how frightened his words made me. I followed him out and we walked up the hill and sat down, with the house beneath us. I said:

'What's unhappy?'

I couldn't understand how a grown-up could be unhappy. That was something it was my privilege to be. That a grown-up, and my mother in particular, should be unhappy shattered my picture of what life was like.

He didn't answer.

'What's unhappy?' I said again.

'You know what it is.'

'Why is she unhappy?' I asked.

'There doesn't have to be a reason.'

'There doesn't have to be a reason?'

'Not always,' he said.

I held his hand. We looked down at the house in which you lay, your face turned to the wall, unhappy.

'Is it because of me?' I said.

'You? You?'

I burst into tears then. It was a way of coping with all that I had learnt in the previous half hour.

'No, no,' he said. 'It's not you or me or anything else.'

'Is she ill?' I said.

'Not ill, no,' he said. 'She's unhappy. You must be kind to her.'

He stroked my hair, but even though I held him close I sensed his distance. That distance he carried about with him wherever he went. Even then you could sense it. It was part of him, like his ability to talk without indirection, to everyone, always.

'How?' I said.

'How?'

'How to be kind to her?'

'It's not a question of how,' he said. 'You know that.'

Yes. I knew it. But I didn't want to be kind to you. I was hurt too much by what you had done to me. By your exhibition of weakness, of despair.

Am I being unfair?

You could not help what you did, took little joy from it. Yet there was something about your body as it lay there on the bed, with the head turned to the wall, a little bit of white skin showing through the red hair, which seemed like a betrayal. Do you know what I mean?

Perhaps I only mean that mothers are not allowed to be unhappy.

Like a bird, I thought. A broken bird. And there was always something bird-like about you, the way you held your head, the way you pranced on those very high heels, your manner of darting away as though you felt trapped as soon as you began to talk to anyone.

Beside you I always felt heavy, clumsy.
I said to him: 'She's like a bird.'
'Like a bird, yes.'
'Not human,' I said.
'Yes,' he said. 'And vulnerable.'
He stroked my hair and we looked across the valley at the blue haze of the sea and the mountains beyond.
'Always remember,' he said. 'You are much stronger than she is.'
'I'm not,' I said, and began to cry again. It wasn't fair. 'I'm not stronger,' I said. 'I'm not. I'm not.'

I think of the two of you in your space. I move you about in that house, from room to room and within each room. I move you out into the surrounding landscape and then bring the landscape into the house. I see he was right when he wrote: 'The possibilities are endless. The retreat from Moscow or the Last Supper mean nothing to us any more, but there is more than enough in just one room to keep us occupied for a lifetime. Think of all the different hours of day and night which a room experiences. The silence and darkness of the night. The moment before dawn, before the birds break out into song. The slivers of light in the corners, on the table, touching the fruit in the bowl. And all the seasons, late afternoons in Autumn and Winter mornings and that period after lunch in high Summer. And then the ultimate mystery, the fact that a room has been constituted as it has by people whose lives are passed in them.'

And elsewhere in that notebook: 'You have to find a way through it. A way which will do justice to the passing of time, to the fact that nothing stands still, nothing opens itself to our gaze but always retreats, vanishes, turns into something else. And yet to give that fleeting quality a

solidity without turning it into a monument.' And: 'Don't let it dazzle you with its richness or you will lose your way, but don't reduce it to a scheme either. Don't ever allow yourself to feel you don't have enough time. Because time is on your side. Your time, the time you take to work, the time allotted to you on earth, is not something to be resented but to be incorporated into whatever you are doing. Accept it and work with it.'

And I think I know what he meant. Because he was really always concerned with that, with time passing, but also time as a means of conferring reality on the world, time as a necessary and beneficent element, an element of growth, of possibility. He wanted to make us see the miracle of it, of the fact that this one moment would never recur, ever, in quite the same way. So his work is never simple description, it always includes a sense of the before and after. And so makes us think that we too who look at it may look for a moment and then be no more. That the world is as it is and not otherwise, that was the source of his continual surprise. 'You've got to be agile,' he wrote. 'You've got to pounce when you need to. But also learn to lie in wait when you have to.' 'We have much to learn from the great cats,' that was one of his favourite remarks.

Did he pounce on you? The cat on the bird? You never talked to me about the early days, and neither did he. You were as you were and it was no use trying to imagine what you had once been. But I think of it sometimes. The bird and the cat. Though in his daily life he was hardly a cat, more a monkey, or a child, with his puzzled expression and his way of stroking his moustache with the forefinger of his left hand as he looked quizzically out at the world.

I move you about the house. 'When you get stuck, change position,' he would always say. 'Try something else. Keep in motion. But the best times,' he said, 'are the times when you don't have to do any of that, when the pressure of the material, of the idea, keeps everything

moving so fast you have difficulty keeping up with it. When the least promising motif suddenly yields a whole world and more. Material for an infinite number of pictures.'

It's hard for me not to think of you. No. It's impossible. I have tried travel but that has not worked. I have tried busying myself with other things, but that has not worked either. I even tried taking the fight to you and keeping a notebook by my bedside in which to write down my dreams. First I thought I would write them down in the morning, but it's extraordinary how even the most vivid dreams tend to vanish if not transferred immediately to paper. So at whatever hour of the night I woke up, if I had just been dreaming, I would put on the light and write down what I still remembered. At first I was afraid I would not be able to get back to sleep again, but that proved to be no problem. I have always been a sound sleeper.

I found though that although I had started to keep a record in order to exorcise my dreams, the fact of keeping a record seemed on the contrary to encourage me to dream. I seemed to be learning to dream as one learns to swim and regular practice only made the whole thing run more smoothly. The only trouble was that I found myself starting to dream what would look good written down, I found myself beginning to dream in order to have something to write down.

I thought then that things would improve if I ceased to write down my dreams, but all that happened was that I ceased to dream. Or, more probably, that I ceased to remember my dreams, which only means that they were fulfilling their function of letting me get on with my life.

Now I have taken to sitting here in the evenings, when I get back from the surgery, staring out of the window at the

building opposite, at my reflection, and talking to you. I catch a glimpse of myself, half-way between the two buildings, suspended, like a tightrope-walker, high up in space, with the room around me.

Sometimes a light goes on in the flat opposite and then I and my room vanish at once. Apart from the fact that it seems to be an old couple I know nothing about their lives, across the street. I know nothing more about them than I did before I acquired the habit of sitting here at the window, in the evenings.

If someone had told me before it happened that this was the way I would mourn you I would have laughed. But I suppose that is what it is. I begin to wonder if there will ever be an end to it.

'You never come to see us,' you said, the last time we spoke on the phone. And I wanted to say: 'But you don't want me, do you?' Though I knew that if I said that you would only reply that I always rejected your overtures. And you would be right. But what you would not say was that you had hoped I would reject them, and that that was why I did so, that if I had sensed that you wanted me to come I would have done so without hesitation.

'Look,' he said to me as we reached the bottom of the stairs. 'He's at his little window.' And there was Freddy peering through the banisters and barking and wagging his tail. You could tell he was wagging his tail from the way his head and neck were moving.

The house felt dreadfully empty with just him and the dog there. 'What are you going to do now?' I asked him.

'Carry on,' he said.

'I mean practically,' I said.

'Alex will come and stay for a while,' he said quickly and I wanted to say to him: 'No don't worry, I have no intention of foisting myself on you.' But couldn't bring myself to do so. That would have suggested that I had actually thought of it and he would have panicked again.

51

'When it's my turn,' he said, 'I want you to put down the animals.'

'When it's your turn?' I said.

'I want you to promise.'

What about Alex? I wanted to say. Why do you have to ask me? But he had, and all I could say was: 'Of course, if that's what you want.'

He obviously wished to be on his own. There was no reason for me to be there. The house was so silent, though it's not as if you had ever been particularly noisy. Just that there was a sort of oppressive silence, as if we were both of us listening for something even as we were talking, and hearing nothing.

'If there's anything you want,' he said, and gestured vaguely.

He insisted on taking me all over the house.

'If there's anything you want, take it.'

I followed him up the stairs. He stopped on the landing and said: 'She was always imagining her own death, you know.'

I waited for him to go on, if he wanted to.

'She thought I wanted that,' he said. 'That I wanted only to be free of her.'

I waited, standing with him on the landing.

'Not all the time,' he said. 'But more and more often these last few years.'

There was nothing for me to say.

'Can you understand it?' he said.

I shrugged.

He went on up the stairs. I followed.

I have written down two questions for myself. Did I ever tell you? Questions I thought I ought to answer.

What do we want out of life that makes us so dissatisfied with whatever is given?

And: who is to blame for these wants of ours?

I thought if they were down in front of me in black and white it would be easier to answer them. I thought I would simply sit here till they were answered, and then I would know.

I have always been able to solve problems. There is no problem that, once formulated, cannot be solved. That is perhaps the one thing he taught me. Not in so many words, but by example. If there is a problem there is a solution. If we don't find a solution that means we don't want to, and that means that it was not really a problem in the first place.

Well, I have found the answers. What we want out of life is what we obscurely sense has to be our due. And no one is to blame either for the desires themselves or for their frustration.

I have found the answers, but they have not been worth anything at all. Perhaps that is the difference between art and life.

I think what I learned that day, when I entered the bathroom and looked down at you in the tub and then turned and saw that he would never answer my silent question, was the lesson of mortality. I suddenly understood, though it was not till many years later that I grasped what it was I had understood, I suddenly understood that there would come a time when you would no longer be there.

It takes a long time for such things to filter through. And even now I ask myself: if I knew that all along, why should it have upset me so, that you should banish me while you were still alive?

I remember the first time I used that word, banish. You

rounded on me: 'Who's talking about banishing?' you said. 'What else would you call it?' I said. 'What a melodrama,' you said. That was always your way. If I told the truth you accused me of being melodramatic. So perhaps I did become more melodramatic. To live up to what you expected of me. Or out of some other hidden impulse. When I said you were destroying his life you called it melodrama. When I told you to pull yourself together and live more responsibly you said I was overdramatizing things. When I warned you that he might not be able to stand it much longer you turned away in your bird-like fashion, and clopped into the kitchen on your high heels. When I followed you and repeated my point and you saw you would not be able to shake me off you laughed in my face and said: 'Melodrama.'

Didn't you see that I was playing the part you had set out for me? Of course I was odious. Of course I was impossible. That was what you wanted me to be. Then you could dismiss me more easily. I submitted to your wishes, as I had always done. If you wanted a daughter who was anxious, assertive, dependent, and submissive, I would be that daughter.

I should have known better. No good can ever come of pandering to a person's wishes like that. When patients come to me with this complaint or that I always tell them: 'Be truthful with yourself. Tell me why you have come to see me.' Most of the time they do not understand. They resent me for not immediately prescribing what will cure them. And sometimes, of course, I give up the fight, do in turn what they secretly want me to do, out of sheer fatigue.

I get so tired, so tired. When I come home after a day's work I am really so very very tired. You cannot understand that, you who never did a day's work in your life. You will tell me modelling was no joke, but how much of that did you do? He quickly took you away from all that. And even then you could at least keep your mouth shut, your mind to yourself. There was not that continuous sense of having to

54

reassure others, be polite, understanding, careful.

Perhaps that explains my mood in the evenings, why I have no wish to see anyone when I get home. Why I have not answered any letters these past few weeks. Even let the phone ring and not found the strength to lift up the receiver. Why I have not bothered to turn up for appointments.

A job like this takes its toll. I am reasonably strong but I have suddenly had enough. And yet the work does not seem to suffer. No one notices and I myself am not without energy. It is only when I get home that the lethargy over-takes me. When I get home and sit down here, at the desk, facing the window. It is as though I had spent the whole day just waiting for this moment. This moment when I could sit here and talk to you. As if the rest of the day were only a tedious and necessary prelude.

There is much I want to say. I want to tell you that I have perhaps misjudged you. That it was perhaps not your fault so much as his for making you what you were. You did what you could but in the end it got to you.

Not that I blame him either. He did not do anything deliberate. But his feelings were not reserved exclusively for you, as I have sometimes thought, but for his work.

And what does such work mean? I know that almost despite himself he has become successful, famous even, but in the end what does it mean? How many people are going to look at it? And, looking, who benefits by it?

That never seemed to trouble him. There are things you don't question, he said. I may not be very good, but *it* is good. There was no arguing with him. He seemed to know just what he wanted. I suppose that was his secret. So few of us ever do.

I don't know why I say these things to you. I suppose I need to tell you what I think. I suppose there comes a time when everything has got to be said. I don't know what drove me to start. What drives me to go on. But I have to speak. I have to tell you.

He said to me once: 'She doesn't want to listen to you. It tires her to listen.'

Never mind.

I think perhaps it was he who drove you to become what you did. It was he who forced you to act as you did. Though he seemed so kind, was so kind perhaps, it was his kindness devoid of feeling that drove you to do what you did.

I had not thought about this before. But now I feel it may be right.

How can one live with a customs officer for fifty years?

When you turned your face to the wall and cried he sat in a corner sketching. When you sat at the table, your face in your hands, he watched and sketched. When you went into the bathroom and turned on the water he followed you and settled down with pencil and paper in one of the chairs in the corner.

How could you deny him? It pleased you, in one way. It flattered you. There is no doubt that at first, at any rate, it did. 'Don't you ever want other models?' you asked him. And he smiled and said: 'Some people see the same thing in a thousand different women. The interesting thing is to see a thousand things in the same woman.' That is what you told me. That is what he said to you.

'No two moments are the same,' he would say. 'In one room, one person, there is enough to keep a hundred painters busy for a hundred lives. If we only knew how to look.'

You didn't understand him. You thought it was your body, your personality, he was talking about. It was only as time went on that you began to see what he might have meant. That another body might have suited him just as well. Another room. It just happened to be you.

Yet how could you challenge him about this? You did make scenes later on, I witnessed them, but you never asked him outright if he loved you. As if, even after all those

years, there was a shyness between you. Things that could not be spoken. But were felt.

What you wanted, I think, as time went by, was to disappear entirely, to efface yourself from his presence. There was something that was killing you in his even-handed depiction of everything around him. In other words, of you.

At times you thought he could not do without you. He needed your presence as the final stamp of reality on his life, even if he rarely addressed you directly, seemed for days on end not to be aware that you existed. But if you had gone he would have been aware.

You resented his friends. With them he seemed able to talk. With them there was a sense of communion, of communication, which seemed never to exist with you. Or not any longer.

It was as if you were saying to him: 'I am a bird, not a person. Find the person. Please. Help release the person imprisoned within me.'

But he made no effort to do so. Merely painted you as a bird with a person trapped inside. Not literally. That was not his way. 'The trouble with Surrealism is that anything goes,' he used to say. 'Whatever you do can be justified by an appeal to the unconscious. I can't work like that.' He was always faithful to the world of appearances. Yet one could sense the bird in you from the way he made you turn your head. From the way your hand trailed across the table-cloth.

When you asked him to stop sketching you in the bath he made no fuss. Merely spent more time painting, working up earlier sketches, using his memory. And there you were, upright and bent over and stretched out, stepping into the tub or coming out of it, leaning over to turn off the taps, powdering yourself at the mirror or sitting down and pulling on your stockings. You multiplied, proliferated.

When you begged him to stop he said: 'No. It's my life.'

'And me?' you said. 'Am I not your life too?' 'No,' he said, 'you are yours.' You knew he could have added: 'Only with difficulty could I do without you.' You wanted him to say: 'I cannot do without you', but you knew he was too scrupulous for that. 'Only with difficulty,' he would have said, and you preferred him to say nothing.

It was easier to talk to the dog. The cats. At least they listened, put back their ears, purred or wagged their tails.

Yet you must have pleased him once. But now you felt so open to his gaze you ceased to feel yourself any more. So you took refuge in the bathroom. Filled up your day with trivial details. Anything to get away from his gaze, his steady hand, the amused twinkle in his eye.

You tried to escape. I know that. Before you moved out into the country. He told me and you told me. How you left one day, determined never to return. And then did not know what to do. Where to go. And wandered round the city streets. And sat in cafés. And looked at your watch. And in the evening returned. And there he was, sitting in the corner by the window, at his little table.

If he had been working you would have gone away forever I think. You would have left him to his work there and then.

But he wasn't. He sat at the table, staring out into the room. The overhead light was on. He who was always so careful to light standard lamps, table lamps, who hated naked bulbs, was sitting there in the ugly light of the overhead bulb. His face was grey. He knew very well what had happened. What it was you had tried to do. And you felt then that whatever he said or however he seemed he could not exist without you. You knew he would have sat there all night and all the next day as well, without moving, in the dead light.

What could you do then except go about your tasks, prepare food, light the table lamps, extinguish the overhead light, sit and talk to him, put food on his plate and hand

it to him and sit there watching him while gradually life seemed to enter his body again?

Neither of you ever spoke to the other about that day and night. But you both spoke about it to me. Because it solved nothing. It resolved nothing. How could it? He would go on as he was and that would drive you further and further into what you were becoming. But you knew that you would never again be able to do what you had done that day. It had been too much for you. You knew then that you could break free only at the cost of your life. That was the lesson you learned that day. What it would have cost you and what it would have cost him. So that whatever staying brought with it, it would be something. It would not be totally without meaning, it would not be the end of everything.

So you became ever more firmly locked one into the other. And all the rest, everything outside that, grew unimportant. Even your child. Me. Outside the daily routine and the animals and the anxiety and the laughter. For there was laughter. When he laughed at something you said. Or you at his expression. Or even as you got into the bath. Or sat down at the table to eat.

You didn't speak much but you laughed. Not with me though. Or anyone else. It was something between the two of you. The remark that provoked the laughter, his or yours, was muttered too low, was too quick, for others to grasp. More than by your silences they were excluded by your laughter.

I remember once I stood on the veranda and looked inside. You were sitting at your usual place, at the head of the table. He sat on one side. You had one of the cats on your lap. Nothing moved in the room. The longer I stayed outside the more difficult it was to enter. Then he said something. His lips hardly moved but you looked up quickly and laughed. I could hear nothing but I could see you. You had thrown back your head and your body was

shaking. The cat jumped off your lap and ran under the table. The dog leapt up at that and followed it, then they both reappeared, streaking across the room and out through the half-open door.

When I looked at you both again you were still once more. You both ate, solidly, slowly, seemingly lost each to the other and to the world. Had I imagined your laughter?

Perhaps it was my fault. Perhaps I wanted too much. I wanted you to go on paying the sort of attention to me you once had. When you would play with me. Both of you. And then suddenly it stopped. I came into the bathroom and it stopped. You turned away, refused to look at anyone or anything. He was absorbed in his work. It was as if I had turned a corner and I was suddenly in a different world. Where there was no place for me any more. As if what had gone before had never been. Or had only been a game kept up for a few minutes and then thankfully abandoned. Just like that. Without preparing me.

Perhaps it would have been better never to have started. Perhaps you should have made it plain to me from the beginning that there was no room for me in your world.

But how could you? You did not want to act as you did. And perhaps he didn't either. It was not that you shut me out in order to exist together. It was that each of you had shut the world out, the other included, and me included, of course. But where I wanted to return, to enter, you neither of you seemed to feel that need.

Was it something that happened to you? Or to him? Or to him because of you? Or to you because of him? I think I felt obscurely that each of you was silently pleading with the other but that neither of you could yield. Neither of you could respond.

Perhaps because there was a third person there. Perhaps if I had not been there it would have been easier. Perhaps. Perhaps.

He said to me, as we went round the house together that hot afternoon: 'She wanted it that way. There was something in her that wanted it that way.'

I didn't have to ask him to explain. I knew what he meant.

'It starts out as horror, an agony,' he said, 'and then gradually it turns into habit. It becomes a way of life.'

I had no need to ask him to explain.

Yet I did. In fact he only spoke because I asked him. I asked him about your baths. About the way you turned your head away, kept it like that, averted, throughout a conversation. 'It starts out as horror,' he said, 'and then gradually it turns into habit. In the end she could as little have done without those baths as I could do without my work.'

'Do you feel guilty?' I asked him.

'Guilty?' he said. 'Why?'

'Perhaps you did not give her what she needed.'

'She knew exactly what I could and couldn't give,' he said.

'Exactly?' I said.

'Yes.'

He smiled. Freddy came running up the stairs and he bent and picked him up. Freddy licked his face.

'Did I fail you?' I said.

'Fail?'

'I don't know,' I said. 'Perhaps you hoped for something better. Different at any rate.'

'There is no such thing as failure,' he said. 'We do what we have to do. We are as we are.'

'Won't you admit it?' I pressed him. 'Even now?'

'If we start to explore who is guilty and who isn't we will never get to the end of it,' he said.

'And we must get to the end?'

61

'I mean,' he said, 'We would never do anything else. Because we are all guilty, always. Only I wouldn't use words like that. Most of the time we absorb what others do to us, unawares. The self is a resilient thing,' he said. 'Very resilient. It's only when we start to think that perhaps we cannot recover that it becomes difficult to go on.'

He looked so sad saying that that I had to turn away. I had never seen that look in his eye.

'Come,' he said, 'tell me if there is anything you want.'

'Want?'

'To take away.'

'No,' I said. 'I just wanted to look round. I don't need anything.'

I followed him downstairs.

'I must be off,' I said.

'Wait,' he said. 'I'll just feed Freddy and then come to the station with you.'

I waited in the hall. I felt that if I went into the kitchen after him I would burst into tears and he would be embarrassed, not know what to do.

We didn't speak as we walked down the hill and across the square to the station. It was as if we had spoken too much in that brief moment just before.

'You'll be all right?' I said.

'Of course,' he said. Then added: 'Alex will come for a few days. She'll sort things out till I've got my wind back.'

Even then he didn't ask me. Ask me to stay and help him. I know why. He thought I was anxious to be gone. He thought if he asked I would have no option but to stay and that that would not be something I wanted.

Why did he think that?

Perhaps it was true though. Perhaps he knew me better than I knew myself. Perhaps it was just out of a sense of duty that I asked. How can one tell? One thinks one does something for one reason and later it turns out that it was for quite a different one. He shook my hand at the station as if

we were strangers. Even here, at this moment, I could not tell if it was *his* coldness holding me at a distance or *my own* coldness holding him. If he had made me what I am or I him.

The fact of the matter is that we shook hands and then I boarded the train. Typically, he didn't wave when it moved out of the platform, but he didn't turn away either. He stayed, looking after it, an old man, I suddenly realized, but what did old mean given the intensity of his gaze, its unquenched mischievousness?

He was still standing there when we entered a tunnel and I lost sight of him.

I held him there. I turned away with him. I went into the station buffet and ordered a coffee and drank it at the counter, standing beside him. And then out and across the square and up the hill and back to the house.

Once he was in the house I lost him. I sat in the carriage, staring out past my reflection, at the fields, the hills, the woods and the other occupants of the carriage.

It was perhaps at this moment that I recognized the pleasure of looking out, through glass. Of sitting at a window and not focusing on anything in particular. Of seeing myself and my surroundings float before me, mixing with the world outside. Of sitting like that and talking to you.

I wonder when I will have done with you. I wonder when I will find that we have said all we had to say to each other.

The other day Alex came to see me. As usual when she is in town she was in a rush. She wanted to know how I was. She was worried that she had not heard from me for some time. You know what she is like. She is the soul of kindness and concern.

I waited for her to leave.

She wanted to tell me how he was. She wanted to reassure me that he continually asked after me. She wanted to apologize for having taken my place and to explain that it was none of her doing, that it was only natural, she lived so near, that she should go and stay when she was needed. When someone was needed. Besides, she did not have a highly important job, one on which so many people depended. And anyway he didn't really want anyone. It was only the house that had to be sorted out and someone was required to answer the phone. That sort of thing. And even being there, having her there, was more of a nuisance to him than anything else.

'He does not speak of her,' she told me. 'He does not speak of the past at all. He speaks of the weather, and of the flowers in the garden.'

'It's very boring,' she said. She had to answer his letters, most of his letters, a few he answered himself. And to keep his friends from coming to see him. To preserve his peace and his freedom. 'Nothing but a sort of bodyguard, really,' she said.

She told me I was looking thin. That I must take care of myself and not overwork. She said his life was proceeding as well as could be expected.

I felt like a distant relative. An acquaintance. I felt as if I were looking across at him and at the house from a long long way away.

I offered her a drink but she said she had to get on. She had only called in to reassure me. 'He is hard at work,' she said. 'He is cut up, of course, but he is fortunate, he has his work. Who knows what we shall see?'

What sort of work? And what is the reason for it, this work, which takes up every waking hour of the day and night? Why should human beings find themselves drawn to this kind of work? It cannot be the desire for fame, it certainly has never been that in his case. He took what came

when it came, but he could just as well do without it.

'It's what I live by,' he said to me once. I found that strange. 'What does living by mean?' I asked him. And he said something very odd. He said: 'It's to do with dignity. With making the most of what you are given. That is the only kind of dignity.' 'I didn't know you cared so much about dignity,' I said. He laughed. 'I didn't mean that. I didn't mean being dignified.' 'I realize that,' I said. 'It can't just be pleasure,' he said. 'So often there's no pleasure in it at all. But it has to do with growth, with what the Greeks called *energeia*. Though that makes it sound too private, too purely selfish.' 'Perhaps,' he said, 'we need a word like grace. Freed of its religious connotations.'

I thought of his self-portrait as a boxer, one arm raised to ward off the blows of the world, despair on the face. I thought of the skinny body, the puny arm. Out of what depths of pain and suffering had that image come? Yet surely there had been pleasure in the making of it.

'That's the trouble with talk,' he said. 'So many charlatans are good talkers, so many mediocre artists have profound and inspiring theories.'

'It's the work that does the talking in the end,' he said. 'But no artist can be wholly instinctive. We have to have some sense of what we are up to.'

I wonder if he ever talked to you about that? If he ever did? Towards the end did he feel you resented his concentration on his work, or did he sense that it was, after all, what you loved him for?

I come back always to this: that I do not know what really went on between you. I do not know the first thing about you, either individually or together. Which is a strange thing for a child to confess to her parents. But then our

65

relations were never anything but strange. Your behaviour was strange. Like those animals who give birth too young and cannot understand what has happened. And get up and go away after looking with puzzled dismay at what has suddenly appeared before them.

He took me aside and told me the new school would be much better than the one I was at. That it was for my sake, for the sake of my education, that I was being sent away. And I suppose he was right. I was learning nothing where I was, and at home the tension between you took up the whole of my emotional life.

Perhaps someone else would have responded. Would have reacted. Would have plunged into a new life and used the opportunities that were being offered. But all I could think about was the sense of rejection. It went with me wherever I went. I could not shake it off. You didn't want me and he was the executioner of your will. I felt this as soon as he began to speak. I knew what was coming. I don't know if I had overheard you talking or if I had simply always known that this would happen. Known at any rate from the day when I wandered by accident (by accident?) into the bathroom and saw you lying there, floating in the water, and you looked at me and through me and I saw the panic in your eyes. I knew when you said nothing and I turned and saw him and went up to him and looked at him and he said nothing either. I knew then that sooner or later this would happen.

I think now it was he who wanted me to go. Perhaps he felt it would help you to recover. Or perhaps he simply felt he could not cope with the two of us and you were the one least able to cope alone. Or perhaps he simply did not like me.

I think that now. But somewhere inside me something goes on telling me that it was all because of you. I have tried to see it differently. I know you were ill. I know you were not able to control your feelings, your reactions. But there is

a point, isn't there, at which we all have to take responsibility for our actions. And your action was one of rejection. From the first it was one of rejection. Not, it is true, so long as I did not approach you, actively seek your love. So long as I did not do that you simply ignored me. But when I did approach, when I put out a hand, your response was one of rejection: you turned away. It may have hurt you to do that but it destroyed my life.

He said to me, one day: 'She never thought she would have a child, you see. She thought she was letting me down by not having one. And so she was happy when she discovered you were on the way. So happy.'

'She didn't show it afterwards,' I said.

'She couldn't help it,' he said.

'How can you ask me to believe this?' I said.

'If you had not always been so bitter,' he said. 'So ready to take offence, to be hurt. So clinging.'

'Of course,' he said, 'there is no origin to these things. If she had not drawn back you would not have felt the need to cling. Don't think I don't understand that.'

No. We never spoke about it. He would have considered it a betrayal. Of you, of course.

If there was a betrayal it had taken place long ago.

If you would not acknowledge me then I would not acknowledge you.

Would not answer your letters.

Would not reply to his notes.

'They didn't want me,' I said to Alex. 'That's all there is to it.'

'You don't understand,' she said. 'You don't want to understand.'

'No,' I said. 'I don't want to.'

67

'Even now?' she said.

'There is nothing more to be said,' I said.

'You will go on punishing yourself to punish her?' she said. 'Even now?'

'No,' I said. 'What punishment there was she has suffered many times over. It's simply that there's nothing more to be done in that direction.'

'You are not so very different from her, you know,' she said.

I waited for her to go away.

'In the end you cannot deny your ties with them,' she said.

I had not realized how much I had grown to like my quiet evenings by myself. Sometimes I had imagined I wanted someone, anyone, to look in.

She stood up. I accompanied her to the door. 'You'll see,' she said. 'Give it time. In a little while you'll see where your duty lies.'

I watched her clickety-clacking down the stairs on her high heels. She negotiated the steep stairs with surprising ease. I closed the door behind her but I could still hear her going on down and down. For once I was glad there was no lift.

I move you about, from room to room and in the one room too. Then keep you still, lying dreaming in the old deck chair with the cat on your chest.

I have you come in from the garden holding a bunch of flowers.

I have him sit in the bathroom and sketch you as you step into the big round tub.

Later you acquired a bath. With pipes and taps. Then you began to spend even more time washing.

In the mirror I see you put out a toe and feel the temperature of the water. See Freddy in his basket, in the corner. I see the open window and the curtain lifting in the breeze. I see him sitting on the edge of his chair, his eyes bright, a small smile on his face, the pad on his knees, that stub of pencil hardly visible between his fingers. He looks up and then down at the paper and then up again and then down again. His hand moves in abrupt bursts over the paper.

There was no room for me there.

My place was outside.

Yet someone else would have been able to make room for me. Would have accommodated me as easily as the dogs, the cats.

When Alex phoned I said: 'There is no point.'

'I would like to come anyway,' she said. 'I would like to see you in your own flat.'

'There is no point,' I said.

'Does there have to be a point?'

I put down the phone. She rang again at once.

'Don't cut us off like that,' she said.

I put down the phone again.

It rang again, of course.

I picked it up. 'If you don't stop I will call the police,' I said.

'Just one moment,' she said. 'Just listen to what I have to say.'

I waited.

'Hullo?' she said. 'Are you there?'

I waited.

'I am going to come round,' she said. 'You have to see me.'

I held the phone a little way from my face and waited for her to finish.

'Hullo?' she said. 'Are you there? Are you listening?'

I waited.

Eventually I put down the phone.

I waited for her to come. I waited for her to ring at the door.

I waited for her to knock and make a nuisance of herself until I would have to let her in.

Perhaps she has been delayed. Perhaps her husband has returned unexpectedly from Tokyo or Athens.

It is difficult to remain like this, in a state of expectancy.

I thought she might try to catch me at the surgery.

I thought she might send me a registered letter. Forcing me to sign.

I wait, evening after evening. I watch the light fade from the sky in the West. I am lucky. My window faces South. In the morning I get the sun and in the evening I catch the last light in the sky.

Soon the days will be growing shorter.

The occasional burst of rain spatters the windows but it never lasts.

She will have to come. Sooner or later she will have to come.

In the flat across the street the old couple have taken to pulling the shutters to as soon as they come in from work or whatever it is they do all day. Only then do they put on the lights.

Once they would switch on the light first and then walk about the room and tidy things up. Sometimes they would come to the window and lean out, looking down into the street. Now they creep forward in the dark and only put on the light when the shutters are firmly closed.

I hear the rain before I see the drops on the pane.

When I switch on the lamp at the desk the sky goes suddenly dark outside and I see my room, with me inside it, hanging out there in the void.

It is only a question of time before something happens.

Two

My daughter.
Whom I drove away.
Help me.
Your loving father calls you home. And so do I.

My daughter.
Where are you?
Where are you hiding from us?
My daughter.
Your place is here. With us.
Oh my daughter. Come back. All is forgiven.

You say it was my fault. Why will you not admit that it was yours?

Be that as it may, come back. Come back at once. Your place is here. With your family.

I climb the endless stairs to your flat. One hundred and eighteen steps. I have counted them. I know.

I ring at the bell. I knock at the door. You do not open.

My daughter.

Why do you persist in this behaviour?

Why do you sit at your desk staring out of the window and not answer the bell when your own mother rings?

I know what you think. You think it was my fault. You think it was I who drove you away. But I ask what proof you have. I ask what shred of evidence points in my direction.

And the answer is: none.

I am blameless.

And even if I am to blame, I have an excuse to hand: he gave me and I did eat. Etcetera.

I want to talk to you seriously now. The jokes are finished and done with. I want to talk to you as honestly as I can and I want you to listen with good will.

Not harden your heart.

Is that possible?

Will you do that for me?

No. You will do nothing for me.

Then for yourself? Perhaps you will do that for yourself?

It's not a life, sitting at the window, evening after evening, staring out at your reflection.

Perhaps you think I cannot see you?

The whole world sees you. That is why you are there. You exhibit yourself. So that the whole world may say: that is what her mother drove her to.

What do you expect this to do to me? What do I care what the world says? What do I care if it points its finger at me?

Oh my daughter. Help me.

Your father does not understand. He does not see the pointing finger.

He is blameless.

My daughter.

Whom I drove away.

Who took herself off. To make me ask: what have I done?

Even when you came to see us you did not really come. You had taken yourself off. You were there and you were not there. Your father did not notice. Your father notices nothing that does not concern his work.

Even when I said to you, face to face and mouth to mouth, even when I said: Help! you turned away.

When I sent you letters, thick envelopes with nothing inside them except the message I wanted you to hear: HELP ME — even then you preferred to remain silent.

It is not myself I am concerned about. I can take care of myself. It is you.

You alone are responsible for your life. You cannot lay the blame for what has happened on anyone else.

Do you understand?

To blame someone else is to give yourself an excuse.

You need no excuse.

My daughter. This is your mother speaking. Can you hear me? Can you hear me?

Even if we were to blame, and I am not saying that we were, your responses would be out of all proportion to the crime.

One does not cut oneself off from one's own family like that.

One does not refuse to open the door when one's own mother stands outside, ringing the bell.

One does not crumple up letters asking for help and drop them in the waste-paper basket.

Do you understand what I'm saying? Is there still some human feeling in you?

This is your mother calling. Help me. I need your help.

Your father asks me sometimes why I still bother with you. I answer that one lost sheep etcetera. He finds it perfectly natural that you should have acted as you did. He cannot understand my concern. I say: so long as I am alive I shall be concerned. I say: there are terrible things going on in the world. Utterly terrible. Every second of the day. All over the world. But it is not my task to deal with those things. It is not even my task to cry over all that is happening, in desert and forest, village and city, in the open plain and behind the hedge. That is not my task. My task is simple, I tell him. I have a responsibility towards one person. I cannot turn aside from that.

If you would only tell me what I did. But you won't. Perhaps you don't know yourself. I accept the blame. I accept the blame for everything. But find it in your heart to forgive me. Find it in your heart to make one human gesture.

My daughter.

Your aged mother pleads with you.

Your aged mother goes down on her knees before your door. She peers through the keyhole and sees: your silhouette outlined against the window.

Do you hear your mother knock? Are you so hardened that you do not hear her knock?

Every day I knock. Every day I ring. Every day I climb the interminable stairs and wait, getting my breath back before I put my finger to the bell.

I hear it ring in the empty flat.

Even when you are there the flat is empty, a desert.

You have become inhuman. When you are alone there the flat is not inhabited. The sound waves pass through you. They do not bounce, they do not bounce off you. I see them pass straight through you and bounce back from the window, the walls. But off you they do not bounce.

You have wiped us from your consciousness. You have chosen another path.

I ring at your conscience. I knock at the door of your soul. There is no response.

My child.

Your loving father calls you home and so do I.

Without you this house is empty.

Without you we live in a desert.

Did you try to phone me today? This morning, to be precise, at eleven o'clock?

I was lying in the bath when I heard it ring. There would have been no point in getting out. By the time I reached it you would have rung off.

I wondered if it was you, at last. It sounded to me like your way of ringing. Your insistence.

It rang again as I was in the garden. But by the time I got to it there was no one there.

I thought perhaps you had had a change of heart.

Those endless hours between breakfast and lunch, between lunch and supper.

I lie in the deck chair sometimes by the window. I close my eyes and dream of you.

Why do you never write?

The cat crawls up my body and settles down on my shoulder, between my shoulder and my cheek.

Was it the animals drove you away? You always objected to the smell. The cat smell of the house, you said.

If I had known it would drive you away I would have got rid of them. Much as it would have hurt I would have done that for my daughter.

I don't think your father would ever have forgiven me. But I would have done it.

I thought of hiring a firm of private detectives. To trace you. To discover your whereabouts. I even went so far as to make enquiries. To seek recommendations. A reputable firm. Honest and efficient. I even went so far as to make an appointment.

But what would I have done with the information? How could I have made use of it if I had acquired it by such means?

I do not talk about this with your father. For some reason it is not a thing we talk about. If I had had the benefit of his advice perhaps I would have seen my task more clearly. If I had been able to discuss the problem with him I might have known how to act. But that is one subject we cannot talk about together.

Or should I say it was the first subject we could not talk about? Since then others have appeared, and now there is scarcely any subject that is not taboo.

I might perhaps, once the agency had informed me of your whereabouts, have taken up residence nearby. Have stood at the window and waited for you to go down into the street. Have followed you to work. Have even perhaps sat in the surgery and waited to be called in by you.

But how would you react to the thought of your mother pursuing you? Spying on you? Every one has their own life to lead and why not you?

Is that a reason though for ceasing to write or call, for disappearing entirely from our lives? Are you not part of us as we are of you?

When I talk to your father about it he clicks his tongue. It embarrasses him to hear me say these things. When I ask him for advice he merely turns away. Or surreptitiously sketches Freddy in his basket or the fruit on the table. I am talking to you, I say. I am talking about our daughter. Will you not try at least to pay attention? He looks at me then and smiles. His smiles are inward, not outward. Do you know what I mean? As if he is smiling to himself, not others. Yes,

he says. Yes. I am paying attention. But he says it in such a way that I know I have trespassed. This is something I must not talk about. This is the number one taboo subject and I have brought it up once again.

When I have tracked you down I may rent the next-door flat. In these big apartment blocks in cities the person you are least likely to know is your neighbour. I could sit quietly by the wall and listen to you move about your flat. I would know at once from your movements whether you were happy or not. After all, I bore you. I should be able to guess.

I would wear a hat with a brim. So that if we passed each other on the stairs you would not see my face.

But if you found out? If you discovered I had been spying on you? Would you ever forgive me?

And if you didn't what point would there be in it? If, after a month or two I were simply to go away, what would I have gained? Would we not be in a worse position than we were in before? Because now there would be this too between us, this that I could never talk to you about, if you ever did think of returning. And if I did, if by some accident it slipped out, then you would certainly pack your bags and go again, this time for good.

I am nothing if not far-seeing. I have the time, as I wash, to work out the furthest consequences of every action. It has always been one of my strengths. 'You never act without taking all the consequences into account,' your father used to say.

That was in the old days. It has got harder. Especially where the trivial details of daily life are concerned. Harder to think ahead. To plan for supper by mid-morning, let alone plan for Sunday lunch by Tuesday afternoon. Even to plan for Wednesday lunch by Wednesday morning is sometimes difficult. It is he who has to look in the fridge and write out my shopping list. But he does not always remember either. Not that he minds if there is nothing in the

79

house except bread and a piece of cheese. But I mind. After all, that is my task. Instead of sitting down with the list I go out into the garden and pick flowers. But even animals hesitate over flowers, even cows prefer grass. He does not seem to mind. His work carries him through the day. But I feel I am letting him down. I am not doing my duty. And that thought makes it even harder to concentrate, to think of what will come after lunch. Of the supper to follow.

And then not everyone has his attitude to food. If I miss a meal I feel bad. A bath helps but it isn't the same thing. And you can't eat only bread. It's not healthy. And you grow tired of the sight of it. Besides, sometimes there isn't even any bread. Just a tin of sardines. He doesn't mind that, just as it is, without bread or lemon, just open the tin and swallow down the contents, then get back to work. I was born with a weaker stomach. With a liver that needs looking after. It's because of things like that that it becomes so difficult to plan. It is not always easy to know what will disagree with one's liver, what will give one a headache, what will go with what.

Of course we could afford a maid now he has his regular patrons, but he does not like the idea of anyone else in the house and I don't blame him. I don't either. Besides, I like to do everything myself.

I sit with my shopping list in front of me sometimes and can't get even one item down. I write down oranges and then scratch it out. I write down tomatoes and scratch it out. One really has to start with the main course and work outwards from that. But I cannot think what to make as a main course. Not at that time of the morning. But after it's too late.

He suggested we ask the shops to deliver. But who wants noisy men calling on you at all hours of the day and night? And then you have to tell them what you want. No, I said, I'd rather just go down to the shops and choose on the spot. How can one decide before one has seen what's on offer? He

80

did not press me. He never does. Sometimes I wish he would. If he had insisted I might have yielded. I might have found it easier. But since he said nothing I had no option but to go on doing what I had always done.

It did not seem so complicated once. I have tried to remember when the change occurred, but it isn't easy. You wake up one day and things have changed but you know too that they have been changing for a long time. Quantity converts into quality, as they say.

Now there are tins stocked here for when we need them. If you were here with us we could throw out the tins. They are unhealthy. They lack the necessary vitamins. All the necessary vitamins have been squeezed out of them when they are compressed into those tins. Even if you just came for lunch one day, did not even stay the night, I would do more than open a tin for you. I would cook all your favourite dishes in all your favourite ways. We might start with salade niçoise. Go on to macaroni au gratin. And follow it with a nice leg of lamb. Or perhaps we could have asparagus to start with. I know you have always had a soft spot for asparagus.

Or artichokes. Artichokes take longer to eat. I would prepare a meal that would take hours to eat. Hours to prepare and hours to eat. Then at least we would see something of you.

I would not be able to eat myself. I would be in too much of a state. And I would be too busy looking after you. Looking at you. And then you would get angry. Shout at me for staring and not eating myself. You would accuse me of not looking after myself. Meaning that I was not looking after him. You would tear the leaves off the artichoke and strew them on the floor. I would kneel at your feet and pick them up without a word. I would be down on my knees with Freddy licking my face as you rained more and more chewed leaves on my neck and back.

I would not mind. There is one thing I would not do and

81

that is get angry. But then my lack of retaliation would infuriate you.

You never understood that there are things a mother does for her child. Dirty things that do not seem dirty to her. Wiping food from its face. Changing it nappies. Wiping its behind. A mother is happy to do such things for her child. To her they do not seem dirty. They seem natural.

A father cannot understand such things. He has not got that bond with his child, that link.

Oh my daughter. Your place is here. By your ailing mother's side.

It will not do to say I threw you out. That I was unable or unwilling to cope with you. It will not do at all.

Tell me frankly what the charges against me are. I am prepared to answer them, one by one.

Things were never as you thought they were.

You were taken in by appearances, my child.

Give me one example. I challenge you to give me just one example of the things you say I have done. Or neglected to do.

I have coped all my life. I have done my duty to the best of my ability. How can you say I am unable to cope?

I would have loved you. I could have. Why do you never write? A little note from time to time merely informing us that you are well would not be beyond your powers.

My child.

Alex comes to visit us sometimes. Occasionally she brings Leo, her son. Your father sits in the garden for hours with the little boy. He takes photographs of us all in the kitchen round the table, as he used to do when I first knew him. Sometimes Michael comes too, but his work keeps him

away. It won't last long, this phase of his job, Alex says. A year or two at most. We can cope with that sort of time, she says.

Your father takes Leo and the dog out on to the hills above the house. We hear them laughing as they go and laughing as they return. I don't mean the dog. He only barks excitedly. I mean your father and the little boy. They seem to laugh together all the time. With other people he is solemn, withdrawn, but with your father he laughs all the time.

If you had not been so difficult your father would have laughed with you. If you had not been so demanding. If you had not cried so much. If you had not made such demands on his time and energy.

They say it's because I withheld my love from you. But that is not true. Not at first, at any rate. But how can one go on and on with a child who makes such demands? Who never stops crying?

It was for your own good we sent you to that school. You were wasting your time where you were. The standard was too low. Your father took the decision. The doctors advised us. We wanted to do the best thing for you. A year or two away from home at that stage in your life might have made all the difference. If only you had responded. If only you had played your part. If only you had not entrenched yourself in your bitterness. In your determination to make me feel guilty.

Your father would not talk about such things. He would not talk about you at all. It was I who had to bear the burden of guilt.

Try to understand me. Do not harden your heart. The time is past for recriminations. We all of us only do what we can. We can do no more.

I had been so proud of my skin. One of my best features, people said. It was because of my skin that your father wished to paint me in the first place. Your creamy skin, he

said. And I couldn't bear the itching. Some people might have but I could not. Only when I lay in the warm water did the pain cease for a while. Surely that is not too hard for you to understand. Scrubbing will only make it worse, he would say. Can't you leave it alone? But it wasn't true. I didn't scrub. A gentle sponging was the only thing that soothed it. Not scrubbing but a gentle sponging in warm water, that was how I coped with it.

The trouble we had in the early days. Before we had pipes and taps and things. When what you did was fill a tub with hot water and by the time it was full enough the water was already almost too cold. You put the tub in the middle of the room and stepped into it. He painted me like that many times. Photographed me too. I didn't want him to but he said what interested him was the movement, the totality. What did I care about totality? I was in too much pain to care what he did, whether he set up his easel in the bathroom or simply sat on a chair in the corner and sketched. What did I care? If he wanted it like that I didn't mind.

They said it was nervous. That it was the inability to cope with you that had brought it on. That the only way to get rid of it was to send you away for a while. And the school was better anyway. There was no challenge at the local school. No stimulus. Even the teachers agreed. And then when the itch persisted they said it was caused by my feelings of guilt at having sent you away. Or that perhaps I should change my diet, get out more, take more exercise. I tried everything. They said you should come back but you wouldn't. You made me feel it was my fault when it was his as much as anyone's. Perhaps it had nothing to do with you. Perhaps it was the diet. Or the price I had to pay for having been so proud of my skin when I was young.

If only he had reacted. If only he had challenged the doctors. But he always accepted what they said, smiled to himself and went on with his work. I lay in the bath with my eyes closed. I waited for him to go away. I turned my

head away from him and looked at the curtains billowing in the breeze.

If you had been different none of this would have happened. He would have laughed as he ran up the hill with you. He would not have turned in on himself and taken it out on me. Sometimes the old feelings for him flooded through me, and then I remembered what he had done and I could say nothing to him. I could not leave him and I could not stay with him.

It is intolerable to be looked at like that, dispassionately, relentlessly, day after day. It may be that which brought on the rash. The intensity of his gaze. Its impersonality. It was not me he was looking at. I might as well have been dead, a corpse. Even when I am on my deathbed you will go on, I said to him once. He looked at me and stroked his moustache. I knew it was false. He was not like that. He didn't contradict me. He just waited for me to apologize. To say I had got carried away. When I did, at last, he just shrugged, said: 'It doesn't matter.' But it did. To me it did. I wanted him to respond, take some interest. But he only said: 'It doesn't matter.'

He knew I had said it in a fit of pique. It did not matter to him.

I would go crazy, listening to him murmur that it didn't matter. Why not? Why didn't it matter? What did matter then? I asked him all these things but he only smiled. 'Hush,' he said, 'don't excite yourself.'

'Why not?' I said.

'Hush,' he said.

'Why shouldn't I excite myself if I want to?' I said.

'It isn't good for you,' he said.

'What isn't good for me is your lack of interest,' I said. 'It makes no difference to you if I'm alive or dead. All you want is a model.'

'Aren't you going to reply to me?' I said.

'What do you want me to say?' he said.

'Reply,' I said. 'Don't keep asking meaningless questions.'

'I have nothing to say,' he said. 'You know your accusations are false.'

'Why are you so sure you're the one who knows everything?' I said. 'Why are you so sure you even know what I'm supposed to know and not to know?'

He just went on drawing. I asked him to answer me but he said nothing. When I went on, when I got out of the bath and started towelling myself and kept on shouting at him, he got up and simply left the room.

It was not like that in the old days.

Your presence would have freed us from such degradation.

My daughter.

Help me.

Your mother is a sick woman.

She cannot manage the simplest things by herself.

If I knew you were beside me, even in spirit, I could face the world.

A word from you would make all the difference.

It's not much to ask.

But this silence is intolerable.

Oh my daughter.

If I knew where you were I could at least imagine you. If you had let me visit your flat I would take comfort from the thought of you there.

Why have you not married? Why have you not brought your children to see me?

The trouble these days is that I get distracted so easily.

I forget where I am.

I am lying in the bath and I think I am in the garden. I step

forward to smell a flower and bang my knee against the side of the bath.

None of this need have happened. If I hadn't driven you away none of it would have happened.

Help me. Forgive me.

To tell the truth I didn't think I could cope with a child.

I did not know how to respond to you.

I sensed your criticism even before you could talk. I saw it in your eyes.

Perhaps you were right to be critical. Perhaps you weren't critical at all and I only imagined it.

But that makes no difference, does it?

If only your father had helped me. If only he had understood me. Had not been so neutral. So detached. Leaving me to shoulder the burden.

He had his work of course.

Do you understand what I'm saying?

I took a taxi from the station. I was not going to be deterred. I gave the driver your address and then sat back and waited. Inside the building I did not lose my composure. I took the lift to the fifth floor. I got out and examined the numbers on each of the doors. I rang your bell.

You were kindness itself.

I had not expected it. I didn't know what I had expected, but it was not this.

We talked until it was dark inside the room.

You explained how you felt. And I put forward my point of view.

You showed me round your flat. You told me how you had come by the rugs on the floor in your bedroom, and about Morocco. Or was it Tunisia?

I did not ask why you lived alone.

I wanted to ask but I could not. You would have said it was because of me. You would have said it was my fault. I could not ask on a day when all had gone so well.

You said you were so pleased I had come at last. I said I was, too. You wanted to know about your father. You did not explain why you had acted as you had and I did not discuss the issue either. After all, what would have been the point of explanations?

I did not want to leave. I did not want to have to say goodbye.

Why do you not send me your address? I promise I will not try to see you. Not unless you asked. But at least I would know you were alive. Your father would be able to contact you were something to happen to me.

I am a burden on him. It would be better if I didn't exist.

When Alex turns up he immediately expands. He is happy again. He smiles. He laughs with Leo, her little boy. All three of them go off into the hills while I lie in the bath. I call out to them, asking them where they are going, asking them to wait and I will come with them, but they don't hear me. They are making such a noise they don't hear me. Or pretend not to. And the water is still gurgling in the pipes hours after one has finished running a bath.

In a way I preferred the old system. It was slower. One had to plan each move. To clear away the carpets. To fetch the tub from the pantry and set it down. To heat the water. To get the towels ready. And the soap.

Lying down in a round metal tub is one of the most difficult feats in the world. I am not boasting if I say I was adept at it.

Now you can turn on the hot water and go away and do all sorts of other things while waiting for the bath to fill. Of course if you forget it overflows. There are always dis-advantages to all technical improvements. But it does make life easier. A bath though, for the same reason, becomes less special, less of a ritual.

I miss the old ritual.

But a bathroom is an exciting place to me. A bathroom.

How strange that is. A whole room devoted to washing. In which the bath is the altar.

When I got out they had gone.

Her bag was on the table. I was tempted to look inside. Instead I sat down and waited for them to return.

I suspect him of betraying me with many women. And why shouldn't he, after all? I don't have much to offer him. And if it makes him happy then I feel myself a little less to blame. So everyone is happy.

Why does Michael never accompany her on her visits here?

She says he is in Vancouver, Cairo, Bangkok. His work keeps him flying round the globe. They do not mention his name.

Nobody says anything.

He laughs with the little boy. They stay out for hours. Just the two of them, and Freddy. He won't even leave me Freddy.

Sometimes Alex prepares the meal. I hardly know she is there and everything is done. She can conjure hot food out of nowhere, in no time. I lie on the deck chair and let her get on with it.

He has never painted her alone. Or even sketched her. When I ask him why he shrugs his shoulders.

I remain the one. With the animals, of course.

There is no one else in his life. His real life. Once he painted the two of us, Alex and me, talking. Her head leaned towards mine. It intruded into the picture, from the frame, red. Outside the window the flowers were in bloom. He painted us as though we were adjuncts to the flowers, the sky outside. We hovered in the foreground, her face leaning inwards from the frame towards mine.

Sometimes I think he cannot do without me. That if I go first there will be nothing for him any more.

When they came back I was asleep. Look at her, he said. I heard him. Look at her. Like a flower.

He sat down at the table. Her open bag was between us. He looked at me.

It was so quiet. Just their voices on the veranda, through the open window. I heard him say: 'Look at her. Like a flower.' Then the dog jumped on my lap and I opened my eyes.

The first thing I saw was her bag lying between us on the table.

'You were asleep,' he said.

'I was dreaming,' I said. 'I had taken a taxi from the station and finally made contact with her. We were talking in the living-room of her fifth-floor flat. She showed me the rugs from Morocco in her bedroom.'

'Shall we have some tea?' he said. 'Would you like a cup of tea?' he said to me. He didn't want me to go on. He was ashamed before her.

'We talked till night fell,' I said.

'Yes,' he said.

'Don't you want to hear what she had to say?' I said to him.

'Later,' he said.

She must have brought the cake with her. When she came there was nearly always cake for tea. Home-made, of course.

We sat round the table and chatted. Everyone talked most naturally. Alex had pulled the bag on to her lap and was fumbling inside it. The child had gone to sleep, stretched out on the sofa. The sun and the excitement had been too much for him.

'We must go,' Alex said. And they were outside on the veranda again, chatting in low tones, and then she was gone.

My daughter.

The child I rejected.

Who would not turn back to me.

Who would punish me for my misdeeds.

Tell me what I should have done.

Now there is only the silence. The emptiness. And the sound of his pencil.

I cannot face his gaze. I prefer to look down at the floor. It is best if there is a cat on my lap. Or Freddy.

When I move he says nothing. After all these years. Only sighs.

Is it a life, to be looked at ceaselessly, day and night? The worst criminals have moments at least when they are protected from the sight of others.

In the mornings he walks. 'It needs moving round,' he says. 'I must walk and try to sort it out.'

So he walks and I have the house to myself.

In the old days he could only walk in cities. The countryside drove him mad. 'It sends me back to myself,' he would say. 'It doesn't let me into the picture. It locks me in.'

He talks like that about his work. Let me out. Move around. Lock me in. Not to me of course. But to friends. Dealers. Writers who come and visit. Always leaving a mess behind them. And the smell of their pipes. It is hours before I can get the house free of that smell again.

Now in the country they have ceased to come. The times are not right. Everyone is anxious. We are too far away. Thank goodness. And he has grown used to walking in the hills above the house. Now he hardly ever gets up to town any more. 'I've got it all here,' he says, knocking his forehead with his knuckles. 'I don't need the city any more.'

Nothing but rooms though. Sometimes the veranda. Occasionally a landscape. But not often. 'What's the point of living here if all you do are interiors?' I ask him. 'Even interiors are landscapes,' he says.

I cannot tell him how I dread the sound of his pencil. He

91

sits in a corner of the bathroom and sketches. I have to pretend he isn't there. After all, once I was pleased. 'Shall I hold this position?' I would ask him. 'Just do what you would normally do,' he would say. I was almost sorry not to have to stay like that, holding up my hair, looking into the mirror. But he wanted it natural. 'It all has to do with the idea,' he would say. 'The idea of the piece. If that is good then the rest will come.'

'Everything is a subject for painting,' he would say. 'There is nothing that isn't a mystery. Look at the relation of this plate to that. Of your hand to the edge of the table. Look at the way the light falls on this finger and across. Then look at what happens to the light when the curtain blows. The difficulty, he says, 'is not to be seduced by all that takes place in front of you.'

I do not understand him when he talks like that but it doesn't matter. I listen. Or did. Now he has stopped. Perhaps he talks to Alex as they walk in the hills. Or to Michael when they come together. They are our only visitors. And more often Alex and Leo than Alex and Michael.

'How to paint what happens when nothing happens?' he used to say. I knew what he meant. Nothing happens and nothing happens and nothing happens and all of a sudden there is a whole life gone and you realize that all those nothings were in fact everything.

He is so silent now, but still smiles to himself. That sometimes makes me want to scream. I look at him and I open my mouth to scream. He puts up a hand and says: 'Please. No.'

If he would only shout at me I could shout back.

Do you know what he said to me? He said: 'You make yourself ill, acting as you do.'

Because of what? Because when he was out I had taken one of his pens, the thick felt ones, and a large sheet of his best paper, and I had made a poster. Sent him a message. I had inscribed it ever so carefully. The mask of anarchy. And

pinned it to the wall of the entrance hall. To face him as he entered: THE MASK OF ANARCHY.

I lay in the tub and smiled at him.

He said: 'You make yourself ill.'

'I don't,' I said.

'All your actions are wrong,' he said.

'Thank you,' I said.

'I mean,' he said, 'that you make a great deal of effort for very little result, or else you do nothing at all because the smallness of the result has discouraged you. We should see a doctor,' he said.

'We've seen a doctor,' I said.

'That was a long time ago,' he said. 'Anyway, it was for your skin.'

'Skin is bound up with everything else,' I said.

'Why did you write this and put it up like that for me to see?' he asked.

'I felt like it,' I said.

I lay in the bath. I could hear his pencil. I lay so that he could not see me without getting up. When I was towelling myself and putting on talcum powder I said to him: 'Mask is mask and anarchy is anarchy. The mask of anarchy. Do you get it?'

'There is nothing to be afraid of,' he said. 'I would be with you the whole time.'

'They would put me under observation,' I said. 'I cannot bear the thought of being put under observation.'

'There is nothing to be afraid of,' he said.

'I could not stand it,' I said.

'Putting under observation,' he said. 'That is just a form of words.'

'It is not a form I like,' I said.

'No one would do that to you,' he said.

'What is the point then?'

'The point of what?'

'Of going to see them?'

'So that they can examine you. Help you.'

'I won't be examined,' I said. 'Not at my age.'

'But if they can help you,' he said.

'I need the help of no one,' I said.

All because I had used one of his pens, one of his thick felt pens, and written up my message to him. Because he remembered the last time. Or times. When I had written other messages and left them for him to find.

'Why don't you talk to me instead of writing up messages for me to read?' he said.

'Why?'

I have never seen that book, the mask of anarchy. But I like the title. It corresponded to my mood. The mask of anarchy.

When he came in I had it pinned in the entrance hall.

'We will put you under observation for a little while,' the doctor said. 'It's not serious but we will put you under observation.' When we got out I told your father I had no intention of staying under observation. 'I'm not a prisoner,' I said. He agreed with me. He had little time for doctors himself.

Of course I am not trying to disparage your profession. When it knows its place. In fact I said to him early on: 'If we have a child I want him to be a doctor. Or her, of course. I want him or her to be a doctor.'

Every morning he takes a walk.

He does not know where he is going.

Sometimes it is above the house, in the hills.

At others into the village, through its little streets, and out into the main square with its plane trees and café.

It is important for him to walk. To get the feel of the

94

picture in his body. To test it, he says. To make sure there aren't any holes.

Even when I am dying or just dead he will take his walk. He will ponder the balance of his picture, he will seek to anchor it, he will test it for possible holes.

Why is it so quiet in the house when he isn't there? It frightens me, the quiet. At first I try not to notice it. I try to ignore it. Then it begins to get on my nerves. I find myself going from room to room, restless. In the end it is always the same. I take refuge in the bathroom.

As soon as the water is running I start to feel better. When I finally get into the water I feel best of all.

'What I cannot understand,' he says, 'is why you need four baths a day.'

How can I explain to him?

He does not say how much he loves my body in the bath. I know he does because that is when he is happiest, sketching me in the water.

'If I could I would live in the bathroom,' I say to him. 'I would have not four baths but eight. Eighty.'

'Feel free,' he says.

I have already put one of Freddy's baskets in here with me. It makes it all seem more friendly, more lived in.

The doctors kept me under observation but it didn't do any good. So they left off.

When I am in the bath I cannot open to anyone. I cannot answer the phone.

There is not the time to do everything that has to be done. There are so many things to do that I grow dizzy and can only recover my composure in the bath. But then there is even less time to do what has to be done. After a while, however, as I lie in the warm water and listen to the rumble of the plumbing, all that ceases to matter. I recover my perspective.

And he is so busy. He does not want to see anyone either. It isn't only me. Don't imagine otherwise.

If he wishes to see them he can go up to town.

One day he came back and the water was seeping out of the front door.

'What's happened?' he said to me.

'Nothing. It overflowed.'

'What overflowed?'

'I forgot about the bath,' I said.

'And it overflowed? You didn't realize?'

'No,' I said.

'But where were you? The whole place is under water!'

'It'll dry out,' I said.

'Dry out?' he said. 'The carpets, everything. How on earth did it happen?'

'It could happen to anyone,' I said.

'And you haven't tried to do something about it?'

'No,' I said. 'It'll dry out.'

So he was there all night. With his mops and pails. It's a thing that happens to everyone. Why should I pretend it was my fault just to make him feel good?

I sat in the garden till dawn came. Afterwards he said: 'You can't be left alone any more. You're worse than a child.'

The things people say.

When he is hard at work he wrinkles up his nose. It's a sign of his concentration.

Even Louis stopped coming.

'What have you got against Louis?' he said to me.

'Nothing,' I said.

'You know how he's helped me in the past. He's always believed in me.'

That was when we were still in the flat. In town. 'You can't not open to him,' he said. 'He knew perfectly well you were in there.'

'How did he know?'

'He could hear you breathing on the other side of the door. He could see your eye looking at him through the peephole.'

'He told you that?'

'Yes.'

'As if he could!' I said.

'I cannot make sense of that corner,' Louis would say. 'I lose you at this point.'

'Just the ghost of an echo of Hiroshige,' he would say.

I said to your father: 'Just the ghost of an echo of Hiroshige.'

'What do you mean?' he said.

'That's him,' I said. 'That's Louis.'

'He's always been a staunch supporter,' he said. 'Also, a good friend.'

'I can't stand the ghost of an echo of Hiroshige,' I said.

'You used to like him.'

I didn't want him in my house. Echoing about. 'When I'm in my bath I don't want anyone in the house,' I said. 'Surely that's not an unreasonable thing to ask.'

'But you spend all day in the bath,' he said.

I asked him not to exaggerate.

'If you would let me fix a lock on the door,' he says, 'it wouldn't matter who was there.'

Now at last there is peace and quiet. Sometimes it is too quiet. The fell furies fly by night, I write on a sheet of paper and pin it to the bedroom door. Now he does not even ask me about these messages any more. He takes them carefully down and puts them away in a special folder.

'They are messages,' I say to him. 'They are not Works of Art.'

'I know,' he says, and goes on stacking them away.

'They are meant to be taken to heart,' I say.

'I take them to heart,' he says.

'They are meant to be acted upon,' I say.

'I act upon them,' he says.

Sometimes I write on little strips of paper which I stick on his drawing pad or to his napkin. He picks them up and reads them, then puts them away in his wallet.

'They are not objects of value,' I say. 'They are there for a purpose. The fell furies. The fell furies fly. By night. By night.'

'Yes,' he says.

Where then is the ostrich which will hold up its head? I write, and fold it up and push it down into the toe of his shoe.

'Ostriches hold up their heads when they run you know,' he says at lunch.

'I do not know what you are talking about,' I say.

He looks at me with that inner smile of his and his sad eyes. As we grow older his eyes grow sadder. I have to turn away.

I understand his dislike of visitors. Especially Alex. He does not like to be disturbed. 'There is no point in making a big thing of it,' he says, 'but time is precious.'

I have nothing against Alex but I can see she disturbs him. Her way of shaking the hair out of her eyes. 'I have never liked women with long hair over their faces,' he says. 'In our day women with long hair did it up,' he says. 'They didn't use it to hide their faces but to set off their necks.'

'Perhaps,' I suggested to her, 'you should space out your visits a bit more.'

'Of course,' she said. But didn't.

'There are times when he wishes to see nobody,' I told her.

'No, no,' he said, always so polite. 'That does not include you, Alex.'

He never paints her.

When I found he was painting that other one I put my fist through the canvas. He couldn't believe it. 'You did it on purpose,' he said. 'Of course I did it on purpose,' I said.

98

'You destroyed it just like that,' he said.

'It was not a success,' I said.

'That's for me to judge,' he said.

He tore the canvas into strips and then into smaller strips. He cut it up into little squares with a knife. But he never started again.

It was my best message. Because it made him know that that would have been the end.

Instead we got married. After eighteen years together.

Oh my daughter.

Whom I never had.

For whom I longed.

My body cries out for you.

'It is rebelling,' I said to him. 'It is a rebellion in the ranks.'

'See a doctor,' he said. 'It may only be eczema.'

How can he tell what eczema signifies? How does he know it is not the first sign of rebellion in the ranks?

Oh my daughter.

If I had had you all would have been different. Even if things had been bad between us. Quarrels. Tears. And we had had to send you away for a while. It would have been a real life. Quarrels are real. Tears are real. There is goodness in their badness.

'You would never have been able to cope,' he said. 'It's better like that. You would never have been able to cope. You would have been afraid of a child.'

Perhaps.

He has his work. I haven't been well. It would have been different if I had had a daughter. Not this great emptiness. This great silence.

'There are times when you do not seem to know what you are doing,' he said to me. It is always his way. To tell

99

me what is the matter. To tell me what he thinks. No one else will do that. They turn away. Mutter platitudes. He says: 'You are getting less and less good with people.' He is right. I know I can rely on him.

If I had not been barren.

'It's not important,' he said. But he is happy in the company of children. Yet would not go so far as to adopt. 'We must take what comes,' he says.

That day he washed my feet.

Never again.

Just that day. After the doctor. He washed my feet. And dried them on his knees, in the big towel.

I can talk to you, can't I? Can try and tell you about that day? Him kneeling on the floor with the big towel on his knees and me standing over him, one hand on his head and my foot in his lap, first one foot and then the other, as he dried, gently.

He heard me weeping but he went on sketching.

I could not talk to him any more. He did not press me.

Sometimes we can still laugh together. At lunchtime in the summer, with the windows open. Or watching the kittens push each other out of the basket. Then it is over and there is only the blackness. Even when we are laughing I fear the blackness. I turn my head to the wall. Where is it all going?

His friends come and take him out in their boat. 'She cannot stand small boats,' he tells them. 'She's fine on big ones but sick as a dog as soon as she steps on a small one.'

I hear them go. I lie with my face turned to the wall.

He still paints me in the bathroom. I still have to watch my figure. It isn't difficult. I have the figure of a girl. Who is just starting out. Who is waiting.

How much longer must I wait?

It is true that with my temperament I might not have been able to cope with you. I might have given you the impression that I did not love you. That I did not know what

you were doing here in the world. I might have created you already resenting me. You would have sat in your room, far away, a grown woman, still resenting me. So it is better like this, perhaps.

Just to touch you. Just to feel you.

'Look at them,' he says. 'They drown in their children.' Just to comfort me. 'Their children suck them under,' he says. 'When they come up for air the children only push them under once again.'

He says it to comfort me. I see his face when Alex enters. When the child accompanies her.

'We can adopt if you like,' he said to me. But I knew that didn't appeal to him. Made it too much a matter of the will. And he always said: 'For what life gives you, be grateful.'

And if life gives you nothing?

My daughter.
Whom I drove away.
If I had had you all would have been different.
Even if we had quarrelled.
Even if she had been driven away. Her resentment fuelled.
A grown woman, far away, resenting.
Help me.
Your loving father calls you home. And so do I.

It was after that I began to wash. To wash away the dirt. To wash away my dirt.

'If you scrub like that it will only make it worse,' he said.

'It's my skin,' I said.

'You'll only make it worse,' he said.

The water chugs and grumbles in the pipes. For hours after the tub has been filled the house still echoes with the shrieks and grunts. When you light the gas it lets off a bang as if the whole thing had exploded in your face. An anti-

101

quated system. It needs changing. But then I would be without a bath for two or three weeks and I don't know if I could face that. Besides, I like it as it is. I like the bang and the chugging and the grunts and gurgles. It makes of it a living thing, like a log fire. My friend, my companion.

The steam rises from the bath. The curtains blow a little in the breeze. Outside, in the garden, the birds sing. When I lie like this in the bath it is possible to forget.

But never for long. It is never possible for very long. 'You worry yourself needlessly,' he says.

We no longer talk about the child.

What is the point? We both know what it means. What it has meant.

At times I even think he has forgotten.

Your own father. Who drove you out.

Because I must have sensed that he was indifferent. That he did not want as I wanted. Why should we get married now, after eighteen years of living together, if it wasn't to have children? 'If they come they come,' he said. He tried to humour me. 'Greater miracles have happened,' he said. He thought I had forgotten what the doctor said.

'Watch them,' he said. 'See how they drown in their children.' Friends came to take him off sailing with them. 'Look,' he said, pointing up to where Freddy peered between the rungs of the banisters: 'Look, he's at his little window.'

And kissed me as they left.

I have tried sitting in their little boat. Even on the stillest days the movements gets me. Gets to me.

Now he has ceased to accept their invitations. He senses that I resent it. Besides, since a long time they have stopped asking him. They have stopped coming. I ask him why and he says they are here less often than they were. But I know he is trying to spare me. That I have frightened them away. Like all the others. That he is ashamed for them to see me as I sometimes am. Forgetting to comb my hair. Forgetting to

put on my shoes. Forgetting to make up one half of my face.

If I had had a child all would have been different. I would have got into the habit of neatness. Of order. You have to if you are to build your life round a child. Make life possible for a child. You will find that when you have a child yourself. When you marry and have a child. Because you must not let your own childhood keep you from marrying. You must not sit by yourself in perpetual bitterness. I could never live with the thought that I had done that to you.

After all, we had each other your father and I. There was no need for anything else. Anyone else.

We had each other. And the animals.

I do not know when it started.

When I knew it would not be.

I remember it as that day in the bath. Lying in the bath and knowing suddenly that there was no future. Just knowing. My whole body suddenly understanding.

Do you know what I mean? The absurdity of hope.

I waited for them both to return. I lay in the chair and pretended to be dozing. I saw him look at the message, the poster, then take it carefully off the wall. He said nothing to her. Perhaps she did not see it. At any rate she made no comment.

Afterwards, when she had gone, he said: 'What does it mean, the hour of reckoning is at hand?'

'I don't know,' I said.

'But you wrote it. You stuck it up for me to see.'

'Yes,' I said.

'You must know what you meant by it if you wrote it.'

'Perhaps,' I said.

'What hour?' he said. 'What reckoning?'

Afterwards he sat by my chair and took my hand. We sat like that till it was dark.

Not Alex. No. Someone else. Before. The one with the boat.

He said nothing. There was nothing to say.

103

Now I cannot be bothered with posters any more. I can imagine them, as I lie here in my chair with the cat on my lap. I even get the urge to write them, sometimes. But it means nothing. It does nothing. He takes them down. He puts them in his files. What else could he do?

If you had existed you could have mediated between us. You could have talked to me. You could have made it possible for me to talk to him.

It is quiet, now. He is depressed much of the time by all that's happening. It doesn't stop him painting. On the contrary. 'There is plenty of time,' he says. 'Plenty of time. I feed the picture as one feeds a large animal. I stand and watch it and then, when I sense it is hungry, I feed it.'

In the morning he walks. 'You need to find the place of tension,' he says. 'Without it there are only marks on the canvas. But it won't do to impose tension. It must spring from the subject. Otherwise you get expressionism, with every picture the same, the world transformed into the artist's anxieties. But if you look hard enough you see that there are a thousand subjects for every moment of time.'

I don't understand all he says. He does not expect me to, or even to answer him. But he needs someone to talk to. Talk at. Someone to hover round, be there. Just be there. That's what he needs.

Mother!

I have not thought of you for a long time. I hardly re-member what you look like. Only your disapproval when I left home, your even greater disapproval when you heard it was a painter I was living with. But he charmed you, as he charmed everyone. 'He's just like everyone else,' you said when I first brought him round. 'Only nicer. Fancy that.'

After that you talked to him more than I ever did. To me you only said the usual things. You asked when we would

be getting married, when we planned to start a family.

'I'm not sure about a family,' I said. 'I'm not sure that we want a family.'

'Anyone can see he wants a family,' you said. 'Anyone can see how good he is with children. How his face lights up when he sees them.'

'Then perhaps it's me,' I said. 'I don't want a family perhaps.'

'You?' you said. 'But — you're a woman!'

'I may be too nervous, you see,' I said. 'I may not be able to cope with a family.'

'Too nervous?' you said, and laughed. How your laugh frightened me, even then. 'You don't know what you're talking about,' you said.

'I would not like to have a child and not bring it up properly,' I said.

'What nonsense!' you said. 'You just have a child and then you'll see there won't be any problems. All the problems,' you said, 'come from thinking.'

'I may be too nervous,' I said.

I did not discuss it with him. Only with myself. Perhaps if I had discussed it with him all would have been well. But it's worse than useless to discuss things with yourself.

'You go ahead and have a family,' you said. 'Then we'll see if you're nervous or not.'

I could not face you after that. Not when time went by and you ceased even to ask. I knew what you thought of me. I did not answer your letters. When you wrote to him he simply passed your letters on to me. I knew what was inside them. I tore them in half and dropped them in the dustbin.

So why am I talking to you like this now? Perhaps because you are the only one who would listen? Who will listen?

He has never complained. He has never criticized me. Perhaps it would have been better if he had. He sits in a corner and sketches. Or pins up his canvas and starts to

105

paint. I know every gesture he is making, even if I am not in the room with him. After all these years he is almost an extension of myself.

It is lovely to lie in the bath with the windows open and the curtains blowing in the breeze and know he is at work next door. I hear nothing but I know just what he is doing, just how he is looking. Sometimes when he is tired he comes into the bathroom and sits on the chair, not saying anything, watching the curtains move and the steam rise up to the ceiling, flatten and come billowing down again. When I step out he reaches for his pad and starts to sketch again. Sometimes I resent this, sometimes I wish he would go away. But when he is not there I miss him. When he is not sketching me I wonder if I am really there.

I stretch before the mirror and dry my neck, throwing my hair forward over my face. That is the moment I like best of all perhaps, when I reach the damp hair at the back of my neck and slowly rub it dry.

Or when the light falls across the table and he breaks the bread and eats. No one has manners like his. No one eats with the same combination of dignity and enjoyment.

'You're not eating,' he says.

'I like to watch you.'

He laughs. When he does that I laugh too. I don't know why. It fills me with joy.

There is just the slight creak of the curtain rail because a breeze has got up outside and the curtains are restless.

From the beginning his gestures moved me more than anyone else's I had ever known. The simple gestures of the hand holding the paint-brush. I picked him out among the dozens for whom I modelled. In that grubby room, high up above the street.

'What is it about me that you liked?' I ask him.

'You,' he says.

'But what in me?'

'Everything,' he says. 'Because it's you.'

He never says anything he does not mean.

I laugh when I see him break the bread. I laugh at his pleasure in what he eats.

He thinks about landscape the whole time. 'A landscape doesn't have to be outside,' he says. 'It can be in a room. And people like trees, rivers.'

'An arm, the back of a chair. It is only a question of relation,' he says. 'Bringing them into relation. Finding the point of tension.'

He walks in the hills above the house and thinks of his landscapes. At night he listens to the wireless. The news depresses him.

Oh my daughter.

Help me.

He says: 'Do you not want us to try and do something about it?'

'Like what?'

'We could consult a specialist.'

'No,' I say. 'Have a bit of patience. It won't be long now.'

'What won't be long?'

'Before I am gone,' I say.

He is silent.

'Then there will be peace for you at last,' I say.

'Why do you talk like that?' he says.

I know I have destroyed his life. I have stopped him from seeing his friends. I have refused to have his child. I have made him miserable with my jealousy and obsession.

Do you understand?

You don't, do you? You turn away from us. You do not want to know us.

107

You want to punish us for what we have done to you.

'No,' you say. 'It's not that. Not that at all. Simply that I cannot bear to be with you both. I stifle when I am with you. You are like a hydra, one body and two heads. You crush me with your unity.'

Is that a way to talk to your mother?

You sit in your room in your expensive flat, five stories above the city, and cut us right out of your mind.

You sit like a statue, immobile, unblinking. My stony daughter.

The other day I sent a telegram. I do not have your address but I contrived to send a telegram. I knew what he would say but I had to make an effort. I gave it to him to deal with. I wrote out the message and I instructed him to send it. When I asked him if he had done so he said no. 'Why not?' I said. 'There was no address,' he said. 'You did not try,' I said. 'No,' he said, 'there was no address.' 'Why didn't you ask me to put an address when you took it from me?' I said. 'Why did you say you would do it if you had no intention?'

He put the message I had written out on the table between us.

'If you had told me I would have put the address,' I said.

'Yes,' he said.

'I will have to post it myself,' I said.

'Yes,' he said.

I took it from the table and went into the bedroom to get my bag. Then I thought: If he can't send it, how will I be able to?

I have written you letters and posted them in the box at the corner of the street. Why do you never reply?

You have hardened your heart against us.

You take in the letters and then tear them up. Otherwise they would be returned to me. Otherwise they would be returned with address unknown scribbled over them.

When he saw the poster, the words THE MASK OF

ANARCHY, he laughed. I had to laugh with him. So it turned into a joke, I could not keep serious. Though I was serious enough when I wrote it. And the other messages too.

But he turns it all into a joke. And when he laughs I have to laugh. I can no longer feel angry.

My knee has begun to swell. The doctor says it is water on the knee. It must have happened when I fell in the bath.

He wanted me to put a plastic mat in the bottom, to keep from slipping. I cannot stand those plastic mats. I told him I would rather break both my legs.

I have to hobble everywhere.

Every evening he takes off the bandage and puts on a fresh one.

The other day I hit him. I don't know why. I threw out my arm and hit him in the face. He stopped and put my foot down gently on the floor. He took off his glasses, which somehow had not been broken by the blow, and wiped his cheek with his sleeve. Then he put on the glasses again, lifted my foot up on to his knee again and went on bandaging the knee as if nothing had happened.

Should I have apologized?

Why does one suddenly feel the urge to do things like that?

I could see the mark where I had hit him. Right on the cheek bone, next to the ear.

He has never touched me in his life. Not in violence, I mean.

But I suppose I wanted to provoke him. Wanted him to do something. Other than bandage my foot.

Perhaps I wanted him to kill me. It would be better for all concerned.

When I lie with my face to the wall he sits in the other corner of the room and sketches. I can hear his pencil moving swiftly over the paper.

Sometimes I fall asleep and he is no longer there when I

wake. I turn round but I know already that he is no longer there.

I walk through the house looking for him.

Sometimes he has gone out for a walk.

Sometimes he is in his room with the canvas pinned up to the wall, painting.

I watch him.

Then I go into the kitchen to see if there is something there that I can make for supper.

Why did I turn you against me?

Why was I unable to cope with you?

It has to be said that you were a difficult child.

I know what they say. That it was only because you felt my lack of love for you that you clung to me like that.

But is it my fault that I did not give you the love you needed?

Where does it come from, this love one is supposed to give?

I thought I was giving you all, and more. If it wasn't enough then whose fault was it?

I watch Alex with her little boy. I watch to see what it is she does that I did not do. I see nothing.

Perhaps it is the same there. Who knows how he will turn out, this Leo?

Your father talks to him about his work. 'It is never begun,' he says. 'It never achieves fullness. Not the fullness I want,' he says. 'It always has to be started all over again.'

He says to him: 'Look, in front of the canvas I am speechless, mute. It is as if I had not yet learned the language. After all these years, after a whole lifetime, and each brushstroke is like the first.'

The little boy listens. He stares at him unblinkingly, watching his lips move.

'It's that what has to be said is unutterable.'

'Or else: How can we tell what is the right language? The proper tongue? That which is licit?'

'A painting is a little world,' he tells him, 'that must be sufficient unto itself. They speak of truth to nature,' he says, 'but what of truth to the painting?'

The boy listens. I do not know why but he listens. Perhaps it's the seriousness with which he's being addressed that does it. Then they go out into the hills. I do not know what they talk about. But as they go it is the child who is speaking and he is listening, as intently as the other did a moment before.

If you had not left us he might have talked to you.

If I had not driven you away.

He will not say anything but he cannot forgive me. At least if I had been barren I would have known what I had done and not done. But now he blames me and I don't know what for.

Perhaps though he does not blame me. Merely feels sad. Perhaps it is life that is to blame. But then I am part of that life.

Do you understand?

I want to talk to you. I want to whisper to you. I want to see your sculpted face give way to something human. I want to see you smile at your reflection or take out a handkerchief and wipe away your tears.

Not this unyielding intensity. This inhuman look.

It brings a wall down between us. Between the living and the dead.

Turn to me. Smile.

You sit at your desk high up above the street. I see your reflection in the window.

Turn to me.

You hear what I say but you do not move.

You register what it is I am telling you but you give no sign.

111

When I rang the bell you refused to open.

I knew you were there but you refused to open.

Is that a way to behave? To know that your mother is outside, ringing at your doorbell, yet refuse to open?

He has forgotten you.

He has forgotten that you exist.

Only I remember.

When I said I was coming up to see you he said of course, but I could tell he had forgotten.

He said of course but I could see in his eyes that he did not know what I was talking about.

When I told him you had not wanted to open he shook his head sadly, as if he was ashamed of you, but it was only a gesture. It was only done to give me the impression that he knew what I was talking about.

It was only done to give the impression that he accepted my actions.

He does not accept.

'She was inside,' I told him. 'I knew she was inside. And she knew I was there, outside. But she was determined not to open.'

'She has her own life,' he said.

'I know she has her own life,' I said. 'But that is no reason for not opening to me. For pretending I do not exist.'

'Never mind,' he says.

He wants to humour me. He wants me to feel that he believes you exist when as far as he is concerned you don't. I want to force him to acknowledge you. I want to force him to remember you.

But he will not.

If he said he did not that would be easier. But he says he does.

I have talked to him about you. I have described your day to him. He listens, as he always does, with care, but he does not really listen. He has made up his mind.

I asked him to tell me if I was mad but he only smiled and

said no, I wasn't. 'I would rather you told me if I was,' I said.

'No,' he said. 'You are not.'

Most of the time I know he's right, but sometimes I wonder.

I feel it would be better if I were to die. As it is I only make his life a misery.

'I could not do without you,' he says.

Sometimes I believe him. Though he could. When I go, finally, he will of course be able to.

He listens to me talk and smiles and goes on with his work. Even when I complain about Alex he merely smiles and goes on with his work.

I will not ask him to stop seeing her. I will not stoop to that.

I lie in the bath and listen to them on the veranda outside the bathroom. They laugh as they talk. I want to ask him why he never laughs with me, laughs when he talks to me, but I cannot bring myself to do that.

It would show I cared. It would show I was aware of them. It would show I remembered how once we too laughed together.

I can afford to lie in the bath. I am married to him. We have been together for forty-five years.

Please come back. Come and see us. I will not ask you to stay.

You will heal the rift between us. You will make it possible for us to talk again.

When I try to speak to him now it is across your absent shadow.

'If she was here,' I say to him, 'everything would be different.'

'No,' he says, 'you mustn't talk like that.'

'If we had had a child everything would have been different,' I tell him.

'There are no ifs in life,' he says.

'If I had not been barren everything would have been different,' I say to him.

'Life is as it is,' he says.

'I so much wanted a child,' I say to him. 'And so did you. Admit it.'

He shrugs.

Because I didn't have children my skin came out in a rash. The only balm was in the warmth of the bath. The only time the itching stopped was when my body was under water.

He has no pity. He sits and sketches. He painted me in the bath, submerged. He painted my skin and it went on itching.

What are you doing to my body?

He does not answer when I speak to him. He looks up but he does not answer.

I try to scrub myself free of the paint.

I try to rub myself out.

That is when I began to write my messages to him. When I used his pens and sent him letters.

'What have you done to my skin?' I wrote to him.

He said: 'Do you know how much these sheets of paper cost?'

I did not deign to reply.

'Why don't you speak to me?' he said. 'Why do you write down these messages instead of speaking to me directly?'

I towel myself in the mirror. When he sees I have no intention of answering he ceases to question. But now he locks away the large and beautiful sheets of paper. I think of scrawling over his canvases. That would make him sit up. But at the last minute I always draw back.

I don't know why but I always draw back.

And there are periods when everything goes well. When we play with the animals and the hand does not close round my heart. When the itch ceases and I can even sleep at night.

He takes me walking with him in the hills.

He laughs at me for wearing heels. I tell him I feel lost without them. 'My little bird,' he says. We lie in the grass in the poppies and look down at the house and at the sea in the distance. 'My little bird,' he says, and holds my hand.

It is time something was done about the plumbing. About the entire house, in fact. But when I ask him he says: 'Yes. Soon.'

'You've been saying soon for a long time now,' I remind him.

'It's not easy in times like these,' he says. 'We'll just have to be patient.'

I would like to arrange a meeting with you in the park. We would not meet here or in your flat but in a park.

All you have to do is name the place and the time. I will be there.

In the open if you don't want to talk you can always look at the trees. Or the sky.

I might take the opportunity to do a little shopping before.

We could sit on a bench and talk. I would not look at you. I would look straight ahead.

At first you would be frosty. You would have come only because I had begged you.

Or perhaps you would be there when I arrived. You would greet me as though nothing had happened. As though our meeting, and our long separation, were the most natural thing in the world.

'I wouldn't want you to take a train just now,' he says. 'Even if it was possible.'

'Yes,' I say. 'I understand.'

We would talk without strain. When one of us stopped for one reason or another the other would not be impatient, would wait for her to start again.

Now, when one turns the hot water off the whole house jars and judders. I think it's going to come down on top of me.

The first time it happened I ran out into the garden. When it was over I came back in. He was at his table in the corner. He said: 'You went out without any clothes on.'

'Did you hear the noise?' I said.

'What noise?' he said.

'I thought the house was about to come down.'

'You'll catch cold,' he said. 'Without any clothes.'

'You're afraid of what the neighbours will think,' I said to him.

He didn't answer.

'An old woman running about naked in the open,' I said to him. 'Your own wife. What a shame!'

'You'll catch cold,' he repeated. 'Go and put some clothes on.'

'If I want to I'll stay naked,' I said.

He went back to work. For a long time he does nothing. He stares at the canvas in front of him and you think he's gone to sleep. Then he steps forward quickly and begins to work. Once he starts it goes quickly. He will change it later but while he works it goes quickly. Something seems to take hold of him. He doesn't hesitate.

Afterwards he turns away in disgust. Why have I learnt so little? All these years of work and I've learnt nothing. Nothing at all.

Suddenly I felt sorry for him. Why did I torment him like that? What had he done to me that I should treat him as I did?

'I'm sorry,' I said. 'I thought the house was coming down.'

'Go on,' he says. 'Go and put something on.'

He washed his hands and called the dog. I was suddenly afraid. 'Don't leave me,' I said.

'I'm just going up the hill.'

'Please. Don't leave me. Please.'

'But Freddy. He needs a walk.'

'And me?' I said. 'I don't count at all?'

I tried to hold him but he had gone past me. Suddenly I could not bear to have him abandon me like that. I tried to catch hold of him again.

'Please,' he said. 'Go and put some clothes on.'

'I can't,' I said. 'I can't.'

'What do you mean you can't?'

'I want you here,' I said. 'I want you with me. Just for now. Just for now.'

'But,' he says, 'I promised Freddy his walk.'

When I feel like crying the only thing is to have a bath. Then my tears mingle with the warm water of the bath and gradually I start to feel myself again.

It is impossible to say what he is thinking. Feeling. I have lived with him for forty-five years but I still cannot tell.

It is difficult to look at him because when you meet his gaze its intensity almost spins you round. He smiles inwardly and touches his moustache with his left hand. Sometimes he laughs out loud. He doesn't realize the power of his gaze.

When his father died he didn't mourn. He went to the funeral, of course. He put away his paints and his canvases and put on his dark suit and went to the funeral. When he came back he sat and looked out of the window. He sat for a long time. Right through the night. But he didn't mourn. His expression did not change. The next day he took out his paints and his brushes and carried on where he had left off.

And the same when his brother died.

Michael and Alex came to see him. I gave them tea. They talked about him but that was all there was to it. When they

had gone he stood in front of his canvas for a long time, examining it. Then he set to work.

Now when Michael is away Alex comes to see him. I give her tea. I give the little boy a glass of milk. Sometimes it is Alex who makes the tea. She treats the house as if it were her own.

If I am in the bath she does not even ask my permission. She goes into the kitchen and makes tea.

They sit on the veranda. I can hear them. I can hear the chink of the cups. And their laughter.

Please come back.

Say you forgive me.

When I told him I was going to see you he did not actively discourage me.

'Are you sure you want to?' he said.

I didn't bother to reply.

When he saw I was determined, that I had made enquiries about trains, he grew alarmed.

'I don't think you'd better,' he said.

'She's your child too,' I said.

'We don't have a child,' he said.

'I know,' I said.

He didn't know how to respond to that.

When he found me getting ready he tried again.

'If you won't make an effort to see her then I will,' I said to him. 'A parent has a duty to her child.'

'What good will it do to see her?' he said.

'There is a little question of guilt that needs sorting out,' I said.

He did not hinder me. I thought he would, but he didn't. He knew there would be trouble at the station.

I could see crowds in front of the ticket office. I knew then why he had not tried to stop me.

When I got back he said nothing.

'There were no trains,' I said.

'Yes,' he said.

'Tomorrow perhaps there will be trains,' I said.

'Perhaps,' he said.

If I phoned would you know it was me? Would you let the phone ring in your room and refuse to answer?

Would you watch the receiver until the ringing stopped? And then turn back to the window?

I got as far as asking the operator to make the call for me. And then I cancelled it. When she asked me for my number I wouldn't give it.

I have rarely known him so happy. Yesterday he gave an interview to a paper. When they asked him what his idea of paradise was he said: 'Working and knowing that the work is really mine.' When the girl pressed him he said: 'When we think of energy in the modern world we think of something which rushes forward. When the Greeks thought of it they thought of it as a condition.'

'To make something that satisfies the deepest parts of you,' he said to the girl, 'it is necessary continually to break. To break what has already been, what is dead. But this need not be done with large gestures. The large gestures may themselves be dead gestures. I trust more to the small gestures,' he said to her.

Afterwards I brought them tea on the veranda. He was glowing, but tired. The girl said to me: 'I do admire your dress.' I did not pay attention to her. I was busy pouring out the tea. Then he said: 'She admires your dress.' The girl

repeated what she had said. She said: 'Yes I do. Did you make it yourself?'

'This dress?' I said. I laughed at her. She wanted to be nice to me. To show she didn't resent me. I asked them to excuse me.

In the bath I could hear the murmur of their voices on the veranda outside. 'What is *your* idea of paradise then?' he said to her.

'Mine?' she said. 'Oh, I don't know.'

'You must have some idea,' he said.

'Oh no,' she said. 'I'm too young.'

'How can you be too young to have an idea of paradise?' I asked him afterwards. The mindlessness of those girls.

'What do you mean?' he said.

'She said she was too young.'

'She? The reporter?'

'She wasn't a reporter,' I said to him. 'She was an interviewer. That's quite different.'

He sat in the chair he had occupied all afternoon, on the veranda, tickling the throat of one of the cats which had rolled over on its back on his lap.

'I heard her say it,' I repeated. 'She said she was too young to have any idea of paradise.'

'Too young?'

'She didn't say that?'

'Too young to have such a notion?'

He pretended she had said nothing of the sort. 'Perhaps it was something that sounded like it,' he said.

'What did she reply when you asked her about her idea of paradise?' I challenged him.

But he had no memory. Or said he hadn't.

'You did ask her that, didn't you?'

'Yes,' he said. 'But she just laughed. Wouldn't be drawn.'

I sat with them in the living-room while he talked to her. She said: 'Why do you call it paradise?'

'I don't,' he said. 'You do.'

'Why then did you answer my question as you did?' she insisted.

He's a painter. Why should they ask him all these questions?

Yet with visitors he expands.

'What do you mean by break?' she asks.

'The unexpected,' he says. 'What you could not have predicted the second before, but which turns out to be just the right thing. Only the act of moving your hand over the canvas or paper will give you that.'

'And energy?' she says.

'It's like those Japanese flowers that were so popular in my childhood,' he says. 'Most of us remain wrapped up and dry all our lives. Then we die and that's the end of it. But the great artists of the past, they dipped themselves in water, they underwent that baptism. Daily. And so expanded. Opened out. Unexpected colours came into view. And now we know what humanity is capable of. What flowers.'

'That's one of the things that great Piero baptism is about,' he says. 'The immersion. The death of the old Adam. The putting on of the new. But the new is not just another person. It is the perpetual renewal of running water.'

She wrote it all down.

'Why did she leave you her phone number?' I ask him.

'Phone number?' he says.

'I heard her,' I say. 'Before she left.'

'Yes,' he says. 'In case I wanted to add something in the next day or two.'

'Why should you want to add anything?'

'If I thought of something I wanted to add.'

'What kind of thing?'

'Anything,' he says. 'I don't know.'

'Are you going to?'

'To what?'

'Add anything?'

'If I think of something, perhaps.'

121

'You didn't show her my messages,' I say.

'No,' he says.

'Because you were ashamed of them?'

He doesn't answer. He strokes the cat's neck.

'You put everything away,' I say. 'My posters. My messages. They might have interested her.'

'I must go and work,' he says. But stays where he is.

'I don't know why you put up with me,' I say.

He is silent. The cat purrs on his lap.

'It won't be for much longer, anyway,' I say.

He won't look at me. Now I want him to he won't.

I felt funny in the bath yesterday. All of a sudden my heart was beating much too fast. I wonder whether to tell him or keep it to myself.

'If I had given you a daughter it would have been different,' I say.

He will not look at me.

'She would have been Alex's age now,' I say. 'She would have been older than this girl.'

Now he looks at me. I meet his eye, then have to lower mine.

He gets up, settles the cat on the chair. It curls up and goes back to sleep. I think he has gone towards the french windows, but then I feel his hand on my shoulder.

I reach up and take his hand. I put my hand on his and press it against my shoulder.

Oh my daughter.

A word from you would restore us all to life.

That's what I said to him. A word from her would restore us all to life.

I have described your flat to him. The austere apartment

in which you live. Every day I add a few more items. As I remember them.

'Impersonal and austere,' I tell him. 'That's the atmosphere of her flat.'

I have not told him what I really feel. That such austerity is evidence of deep disturbance. That to my way of thinking you are trying to sever your links with life.

To prove what?

That your mother drove you away? That guilt should rest with her for ever?

Talk to me. Please.

Lift up the receiver and dial this number.

'She has set her face against us,' I tell him.

'Yes,' he says.

'It is up to us to make the first move,' I say.

I know I am slowly driving him mad with this business. But it is his responsibility as well as mine. I cannot shoulder the burden alone.

I ask him how he can stand it. Why he does not react. Why he goes on as he has always done.

'Don't excite yourself in this way,' he says.

I know it is intolerable for him. I know I should make a greater effort to leave the subject alone. He needs to live, to go out and see people, to be free, not cooped up with me day after day. I want him to feel free but when the time comes I am afraid.

If you were here you could intercede for me. You could explain to him that I want things to be for the best for him. That it is not my fault that I am as I am.

You might even suggest that perhaps it is he who has made me what I am.

In the eyes of the world he has always been the hero. The self-sacrificer. Why should he leave town? Because we could not go on living in a fourth-floor flat. Why could we not go on living in a fourth-floor flat? Because of the animals? No. Because I tried to jump out of the window.

123

Why did I try to jump out of the window? Because.

No one was to know, of course. He said the country suited him better. But everyone knew.

They didn't ask why I had tried to jump. They only pressed my hand a little more warmly when they came. That is why I wouldn't have them in the house. Because of the way they pressed my hand. To show their sympathy. Intolerable.

Where were you when it happened? Why did you not come to see me? Or did you?

Was that the last time?

You stood by the door. I asked you to come in. You sat on the bed.

There are moments when one wants to gather up everything around one. Everything that has any meaning for one. Parents and lovers and children.

I remember none of my lovers. Only him.

We have been together for so long I remember only him. What happened before I met him does not seem part of my life. It is part of the life of someone else.

If he has done what he wanted to do it has been largely because of me.

How many people can say as much? Feel as proud?

Perhaps you are waiting for the phone to ring? Perhaps you are waiting for me to call?

There is no reason why I should.

Some of the things I have done in my life have been wrong, but nothing can excuse your behaviour.

One can excuse people just so far and no further. One can find reasons for everything, but there comes a point when there has to be a spontaneous gesture.

I said to him: 'I have realized that if I don't call her she is

never going to be able to call me.' I said to him: 'That will have to be how it is.'

'That is perhaps best,' he said.

'I will think of her as never having existed,' I said to him.

'Yes,' he said. 'I think that will be best.'

'Until she takes it upon herself to give sign of life,' I said. 'When that happens I will respond.'

He is working on a large canvas now. He has pinned it to the wall and he stands in front of it for hours, not moving, not painting, watching it.

He does not look at it, he watches it. He waits for it to make a move, and then he pounces.

'That garden,' he says. 'Your presence in the garden.'

I watch him. He has never minded my watching him. They used to be amazed that he never stretched the canvas but he always said he wanted to reserve the right to let the idea dictate the size. 'Does an author know how long his book is going to be before he starts?'

He has never minded my watching him. Or even talking to him while he works. Though he does not reply I know that he is listening.

'I will make no further effort to trace her,' I say. 'I have made up my mind.'

He has picked up his brush and is now mixing his colours, but I know he is listening.

'She knows where we are, after all,' I say. 'If she wants to she can contact us, can't she?'

'Yes,' he says.

'Tell me I'm doing the right thing,' I say.

'You're doing the right thing,' he says.

You have to search for a long time in his landscapes or his garden scenes before you can find the figure or figures. They merge with the rest. But can be found.

He stands in front of the canvas. Once he stood for half an hour in silence, looking, not moving. Then he said: 'You've never done that before.'

125

I said nothing.

He bent forward and examined it. He followed the line of the gash right across the picture. Then he straightened and unpinned the canvas.

'You won't listen to me,' I said.

'And that's why you did this?'

'You won't try to listen.'

He put it carefully away and started to pin another in its place.

'Even if I scream you won't listen,' I say.

'You make no effort to reply to the messages I send you,' I say. 'From the depths of my heart.'

He begins to paint again, quickly, with emphasis. Marks appear on the canvas.

I go out on to the veranda. I sit at the table.

No one has cleared away the tea-things. The cups are still there, dotted round the big table like dancers who have fallen by the wayside. I know which is Alex's. It is stained with lipstick.

He is sitting at the table. It is night. The lights are on in the valley.

'Do you hear the crickets?' he says.

They are so loud here that once you have got used to them you forget they are there. It would drive you mad if you were constantly aware of them.

'Will you walk round the garden with me?' he says.

The moon is so bright that it is almost like daylight. He helps me to get up. He helps me down the stairs from the veranda.

We go slowly round the garden. Now I cannot move about easily any longer.

'You should wear lower heels,' he says.

'I can't,' I say. 'My ankles hurt if I do.'

He laughs.

'They are part of me,' I say. 'I couldn't do without them. Not after all these years.'

But he was right. It was more comfortable with flat shoes.

'No longer your little bird.'

'Always my little bird,' he says.

From the veranda it is impossible to see the hill. The house is in the way.

I wait, listening for the sound of their voices.

There was a time when Alex used to sit with me, or help me about the house. When she came she let Leo go up into the hills with him and she would sit with me, or help me prepare the meal.

Sometimes she would come alone. And when he was working she would sit with me. She would ask my advice about a dress or a recipe.

When he came out and sat with us she would go quiet.

'I didn't know you were here,' he would say.

'I didn't come to see you,' she would say to him. 'I came to see her.'

I had nothing to say to her.

So after a while she gave up. If she came she called out from the garden and he left his painting and they walked up into the hills.

It is so still that I can usually hear them when they come round the big rock and start down the hill.

Sometimes I hear his whistle. As he calls the dog. More often it is their laughter.

The little boy shouts.

Not in the house. He is well-behaved and doesn't shout in the house. But as soon as he's outside he starts to shout.

Even when I am in the bathroom I hear them long before they get to the gate.

Sometimes I lie in the bath until she goes.

They have tea. They tinkle the cups. They talk. I wait for her to go.

He does not ask me why I have not joined them.

When Michael is there, on the rare occasions when he is not in Buenos Aires or in Hong Kong, she asks us to lunch. She knows I will not go.

At first he set off by himself. But after a while he stopped going as well.

'If you want to go,' I say. 'Why not if you want to go?'

'Not without you,' he says.

'So I have to go to please you?'

'No,' he says. 'Only if you would like to.'

'But I told you,' I say. 'I would really rather not leave the house.'

So now she comes all the time. And we have tea.

Even Freddy likes her.

'There's no reason why you shouldn't go if you really want to,' I say.

'No no. It's better for me not to go out too much,' he says.

'Better?'

'For my work,'

'So staying with me has been good for your work,' I say.

'Of course.'

'And for your life?'

He does not reply. He is busy sketching. When he concentrates he sits forward on the edge of the chair and his whole body suddenly seems to come alive.

You would never say he was a man of seventy.

'He is remarkable,' Alex says. 'Remarkable for his age.'

'What does it mean, remarkable for his age?' I ask her. Of course she cannot tell me.

'We are all remarkable for our ages,' I say to her. 'My daughter is thirty-five.'

They have been gone a long time.

Perhaps they have decided to come back by the village and stop there for a drink.

Sometimes I pretend to be asleep when they return. I lie in the deck-chair on the veranda or in the living-room and pretend to be asleep.

One of the cats comes and nestles into my shoulder.

They pay no attention to me. He sits at the table and she and the child go into the kitchen to make tea. When I open my eyes and look at him he says: 'Did you have a good sleep?'

He knows I have not been sleeping. He knows I cannot have a good sleep.

'You're not leaving us?' he says. 'You're not going to have a bath now, are you?'

'Yes I am,' I say.

'But Alex is making tea.'

'Don't wait for me,' I say.

From the bathroom I hear them. The windows are open and the curtains blow a little in the breeze.

I cannot hear what they are saying. They are talking in low tones. I can only hear that they are talking.

Today they have been gone even longer than usual.

There is not a sound in the air.

They have walked through the meadow and up along the track to where the rocks start.

He puts away his canvases now. Even when he has not finished them.

He said nothing to me at the time but now he puts them away as a precaution.

He even locks them up.

129

'Do you want to put the knives out of my reach as well?' I ask him.

'The knives?'

'Do you want to lock them up as well?'

'No,' he says.

'Wouldn't that be sensible?' I ask him.

'No,' he says.

They have been gone much longer than usual.

The sky is quite blue today.

What shall I do? Tell me what I should do now?

Do you know what first made me fall in love with him? I overheard him say to one of his fellow-students: 'She's like a bird. When she walks. When she talks. The way she holds her head.'

He didn't know I could hear. He didn't know I was still changing behind the screen.

I don't know what he meant.

I asked him once, much later: 'Why did you say I was like a bird?'

'Something about you,' he said.

Please come back. Say you forgive me. Say you have forgotten.

I thought I heard them just now. I tried to listen better but their voices faded. Perhaps they have grown silent as they approach the house.

Forgive me. Say you forgive me. That is all I ask.

Your aged mother begs forgiveness.

For what I did to you. For what I am now doing to him.

He found the letter I had written to you. 'What's this?' he said.

'I wrote to her,' I said. 'I had to write to her.'

I watched him reading it.

130

'Why do you write like this?' he said.

'Like what?'

'Saying you want her to forgive you for what you are doing to me. What you have done to me.'

I saw no point in answering him.

'What do you mean for what you have done to me?' he said.

'I don't know,' I said.

'You don't know?'

Then he said: 'What do you think you have done to me?'

I cannot bear that sort of conversation. I got up and went into the bathroom.

Later he said: 'It would be a good idea perhaps to go and see a doctor.'

'Why?'

'A specialist,' he said. 'For your skin.'

'You know they won't do any good.'

'Or someone you could talk to,' he said. 'About all this.'

'All what?'

'Your letters and the rest of it.'

'I can talk to my daughter,' I said.

'Yes,' he said. 'But it isn't the same thing.'

'I don't need anyone,' I said. 'If I can talk to my daughter. If she will talk to me then that is all I want.'

'But if that isn't posible?'

'Why? Why shouldn't it be possible?'

'If she's not there,' he said. 'If she's left the country. If she doesn't want to speak to you.'

'It's based on a misunderstanding,' I said. 'Her not wanting to speak to me is based solely on a misunderstanding. If I can get to see her I will be able to sort it all out.'

'But you don't know where she is anymore,' he said.

I hate that kind of conversation.

'You're trying to humour me,' I said.

'No,' he said.

'She doesn't exist,' I said. 'You know she doesn't.'

'No,' he said. 'She doesn't.'

'And then again she does,' I said. 'If only I can get to see her everything will change.'

'I won't go and see a doctor,' I said. 'I know very well what's wrong with me. I know better than any doctor.'

'Yes,' he said. 'I suppose there's no point in doctors.'

Perhaps they have not really been gone all that long. Perhaps I don't normally notice the time.

He always carries his watch with him. The watch his father gave him. He is never without it. He takes it out and studies it. The other clocks in the house no longer seem to work. Perhaps I forget to wind them up.

When they come I will pretend to be asleep. I will lay my head back against the back of the chair and turn it a little, so that my cheek rests on the canvas.

I like to doze like that. With a cat on my breast, nestling into my shoulder.

We wait for him.

When he is there, sketching, or just sitting, smoking his pipe and sitting, then I don't need to open my eyes. I know exactly what he is doing.

I cannot meet his gaze.

I can tell what kind of pencil he is using. Just by the sound.

I can tell how it is going.

Perhaps when all these troubles are over we can go away somewhere. Move somewhere else. Where they will leave us alone.

I have never wanted anyone else.

Just to be with him. To know that he is there.

132

When I wash I like him to come and sit with me.
Even now.
One grows into the habit of these things.

Three

Cagnes
12 January 1942

My dear Robert,

I have some very sad news to impart. After a month's illness, with the lungs and digestive tracts simultaneously affected, my poor Anna died of heart failure. It's now ten days since we buried her in the cemetery here. You can imagine my grief and the bitter loneliness and anxiety with which I face whatever life is left me.

For the moment I will remain here. My nephew's wife, Alex, will stay with me for a while. After that, we'll see. At least I have my work. That is a great consolation to me. But how can it make up for what I have lost?

Yours ever
Charles